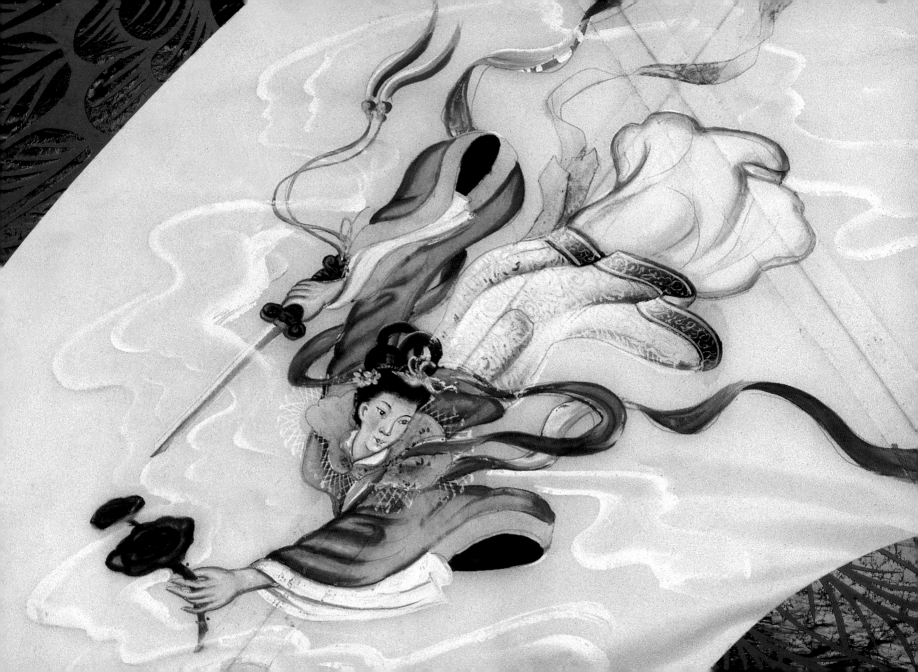

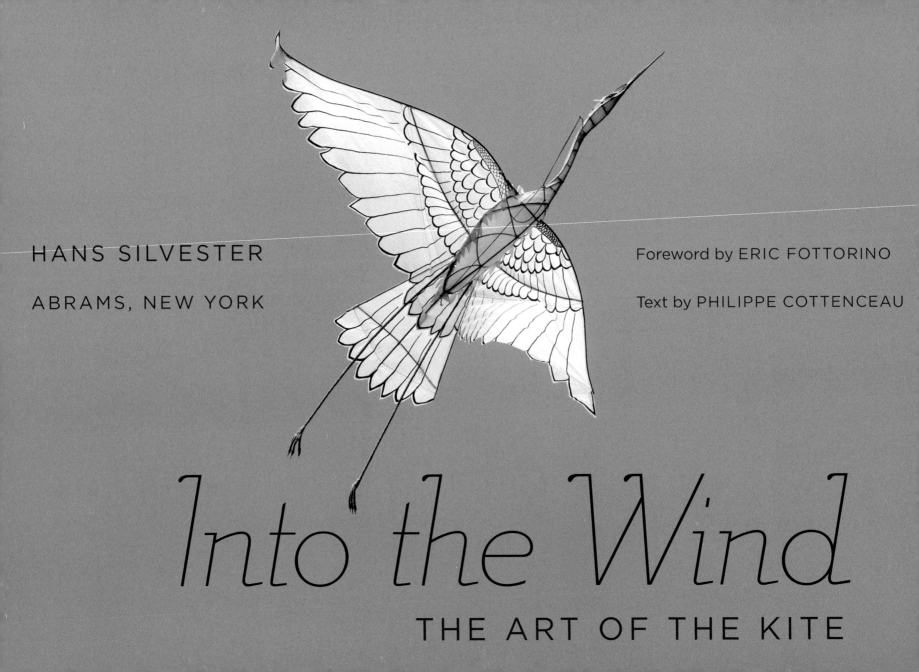

HANS SILVESTER

ABRAMS, NEW YORK

Foreword by ERIC FOTTORINO

Text by PHILIPPE COTTENCEAU

Into the Wind

THE ART OF THE KITE

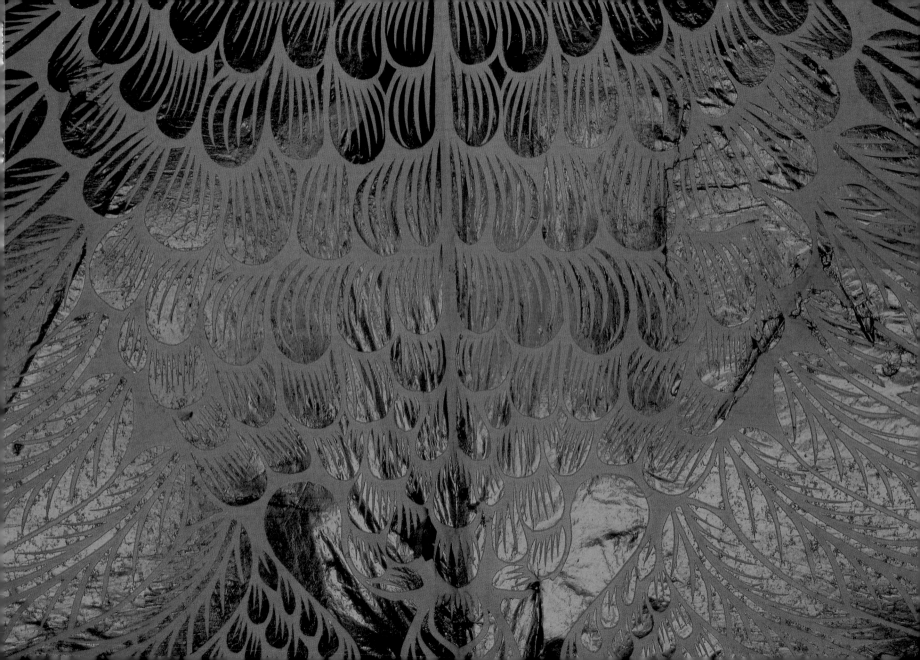

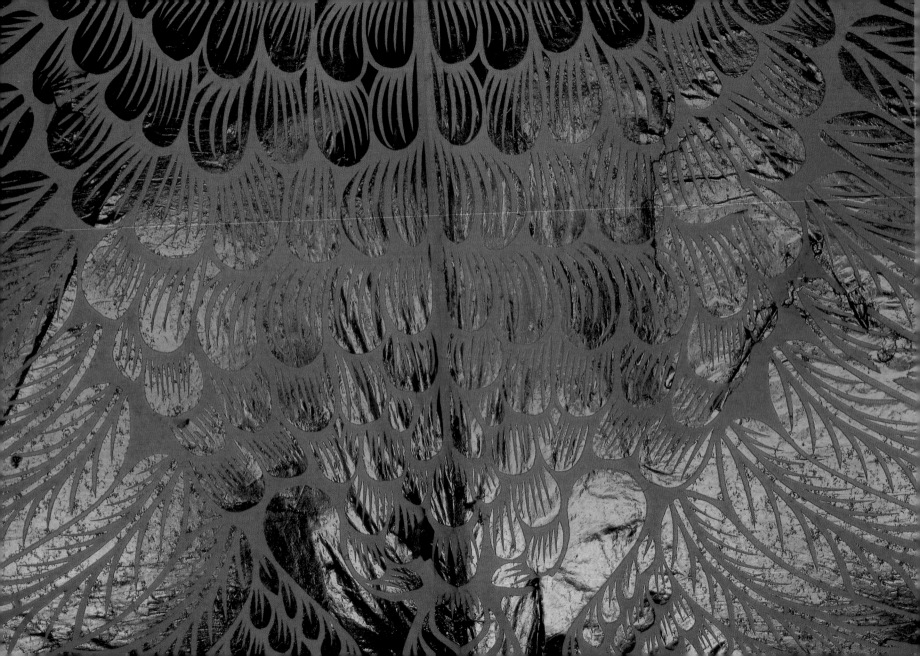

Asia was the birthplace

of the kite. It was created as a divinatory object before becoming a military signaling device. It was then developed and transformed over centuries, but retained a strong connotation of archaic ritual and an aura of impenetrable mystery.

The building of kites is often highly complex, requiring an intimate knowledge of materials like bamboo and tissue paper in addition to other skills that were passed from generation to generation. They include the meticulous profiling of bamboo sticks and a mastery of the slow process of building up a structure, upholstering it, decorating it, and harmonizing its play of transparencies and colors using traditional painting techniques. Last comes the launch, the junction of kite and wind. This is the most critical stage because it exposes the art of the kitemaker to daylight. Any magic unfolding in the sky is the direct consequence of a harmony achieved by the artisan as he builds his model. The wind sets the tone and the craftsman tunes his instrument to the wind. The kite should come alive and even have some autonomy—a characteristic of kites defined by Buddhists as "sleeping." On the island of Bali, for example, kite strings are simply attached to a tree, a window, or a stake in the middle of a field or rice paddy. Before starting their daily tasks, the Balinese attend to their graceful celestial offerings to the sky and their gods. The air is hence adorned with the sight and sound of these "sleeping" kites.

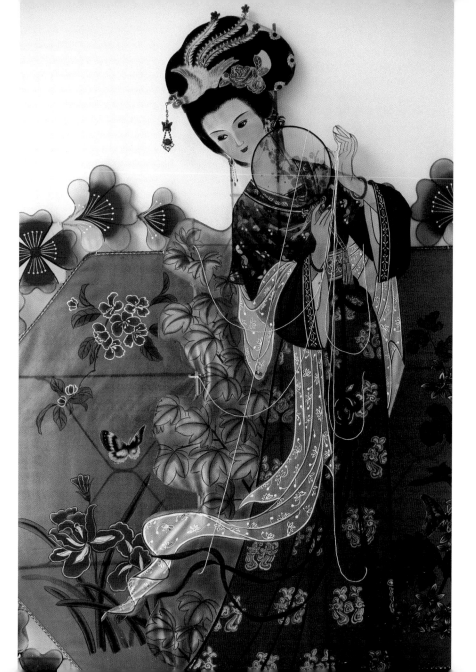

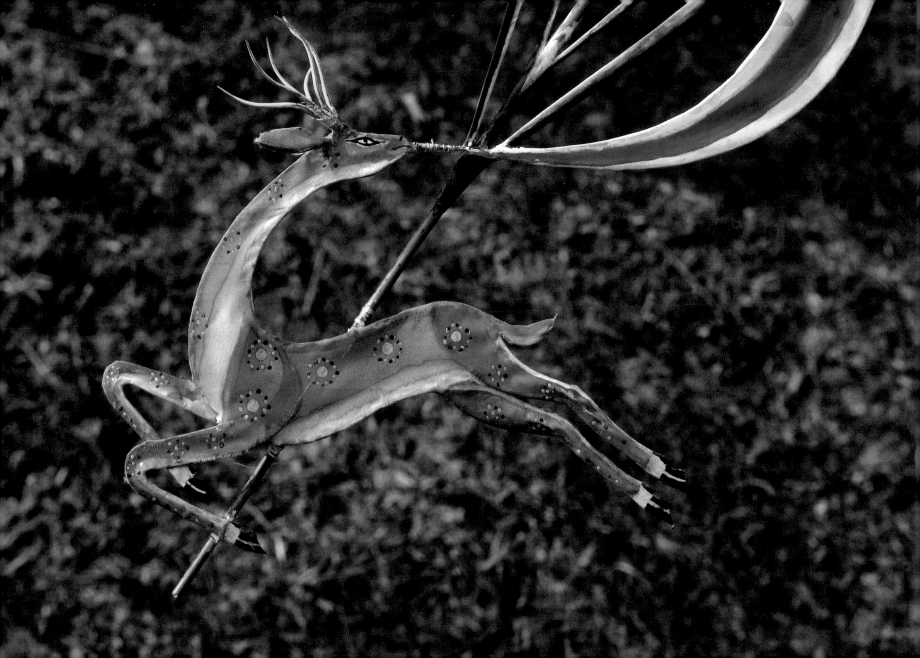

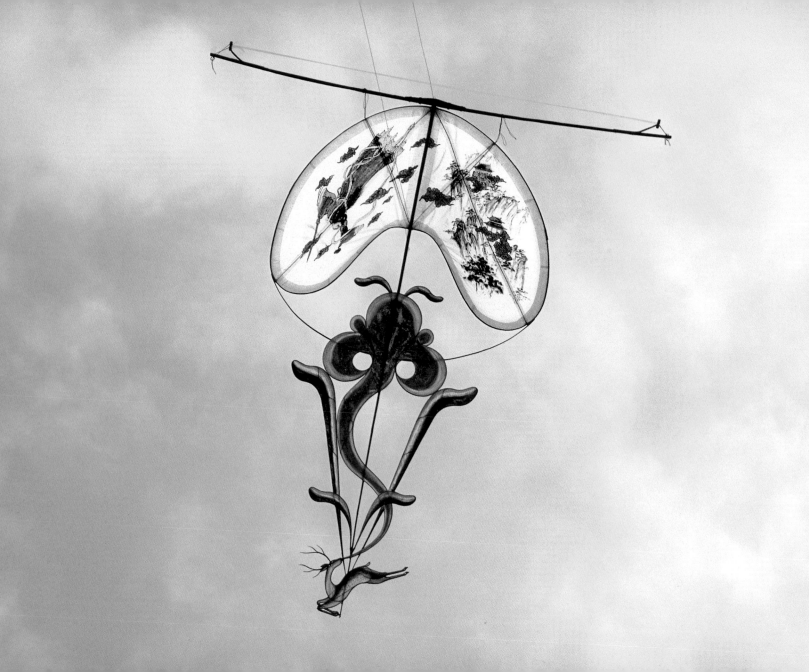

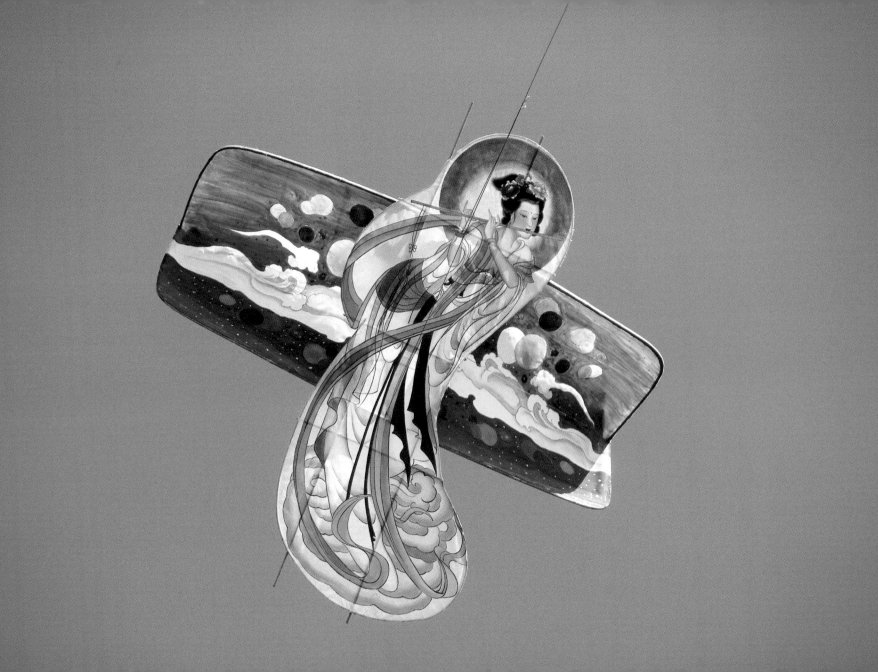

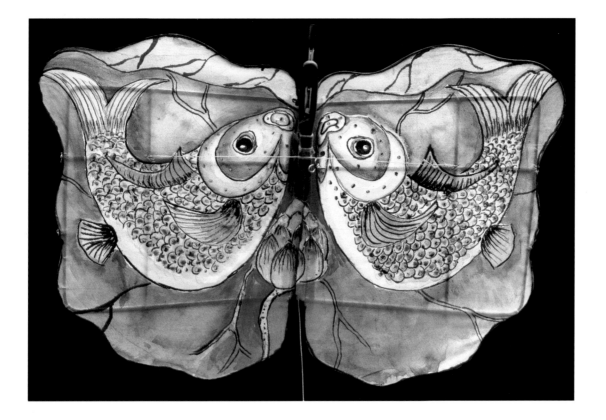

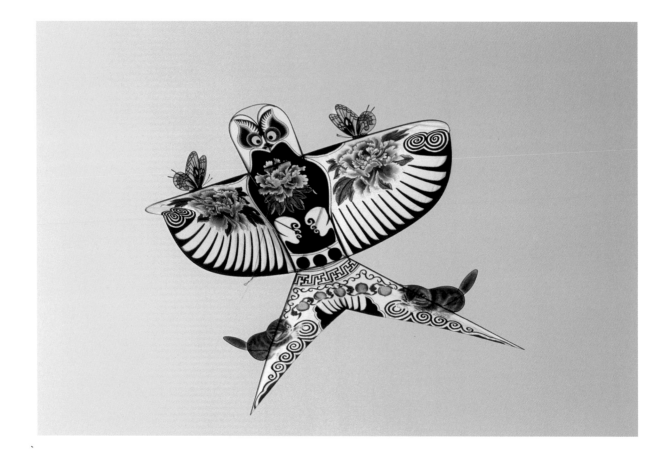

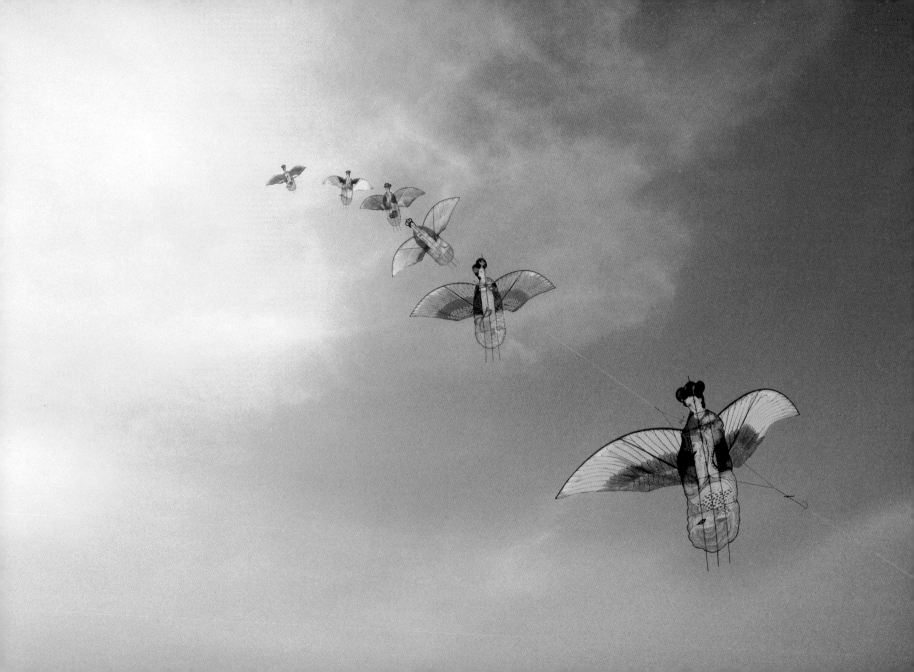

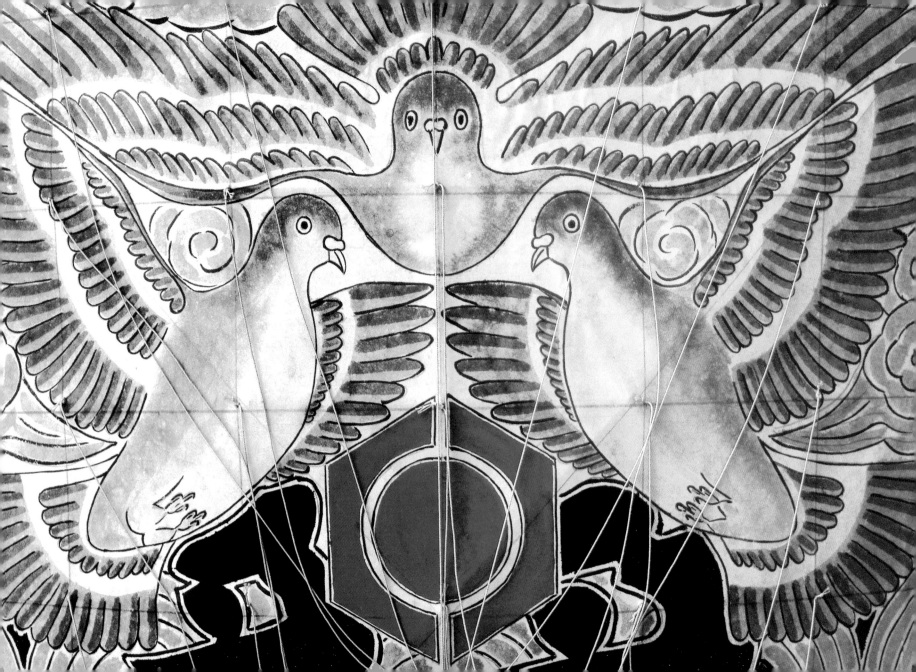

The kite tradition in Japan

goes back thousands of years. The infinite variety of forms and the richness of designs borrow from the Japanese art prints, Kabuki's grimacing faces, and calligraphy and demonstrate the prestige of the masters who devise kites, as well as their importance in Japan's cultural identity. Indeed it is the only country in the world that has five museums entirely dedicated to kites. Certain regions and cities are also renowned for their specific kite traditions and own decorations. The kites of Nagoya, for example, are painted with insects, while those of Hokkaidō depict the first islanders, the Ainu. At Shirone, on the northeast coast of the island of Honshū, hundreds of *o-dako* (giant kites) compete annually in a titanic aerial battle. These creations are made of washi leaves, a type of paper composed of long mulberry fibers set on a bamboo frame. They can measure up to eighteen feet (six meters) wide and twenty-one feet (seven meters) long and are decorated with images from Japanese mythology. The manufacturing of their cords is entrusted to master twinemakers: A hundred days and nights are said to be required for the making of 360 feet (120 meters) of cord, during which time a priest prays constantly so that the hemp will prove strong and the craftsman will be inspired. Competing teams then confront one another from either side of the Nakanokuchi Canal, and victory is won when an adversary is forced back to earth by the breaking of a cord. Quite often the men involved in these brutal jousts end up in the water, dragged down to the canal by their giant kites.

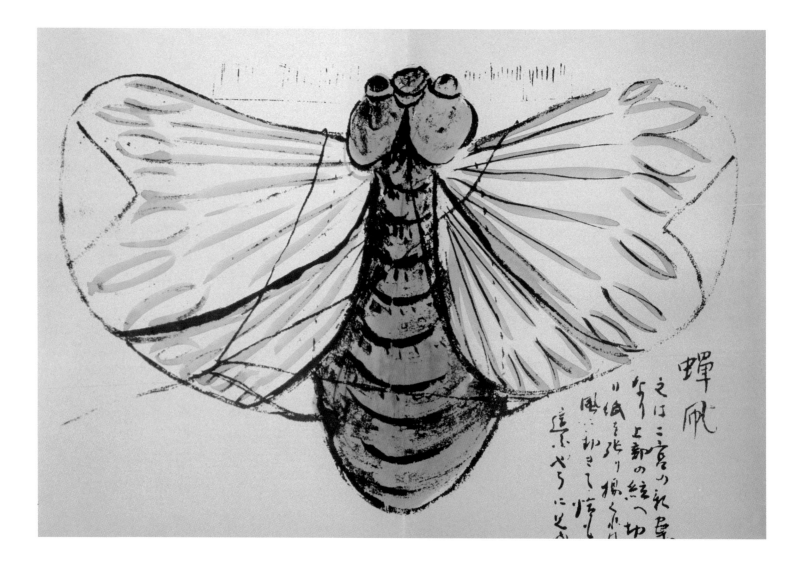

蝉凧

之は二宮の凧雲
なり上部の絵へ切
り紙を張り揚ぐれ
風に切きて悟も
遠くやうにそん

22

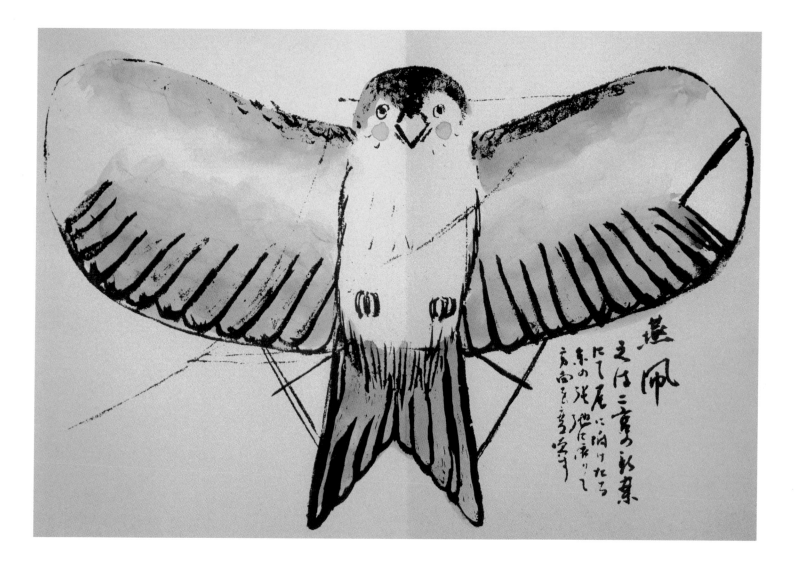

燕凧
之は三尺の紙長
にて尾に向けたる
糸の弛地に来りし
弧面を苦ずす

23

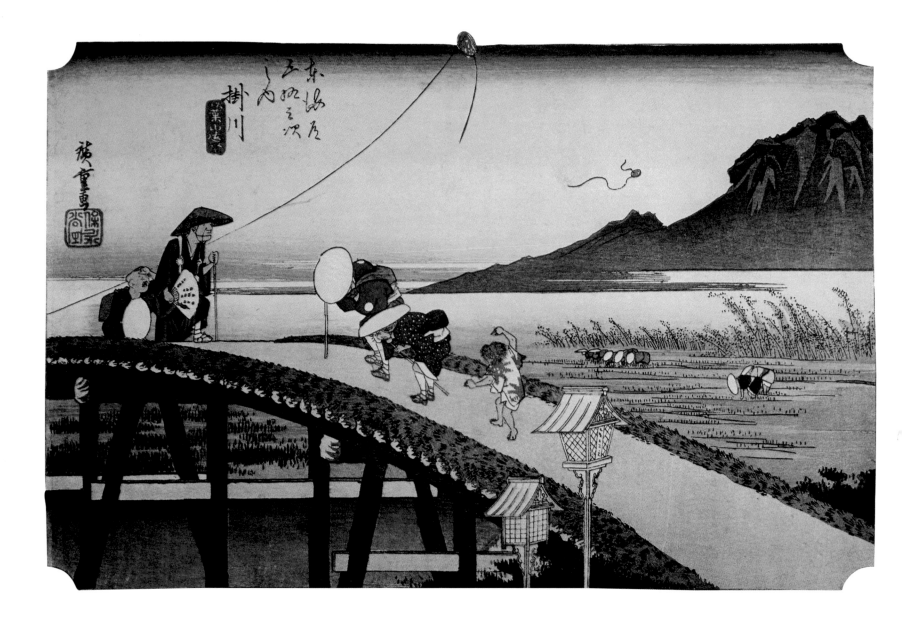

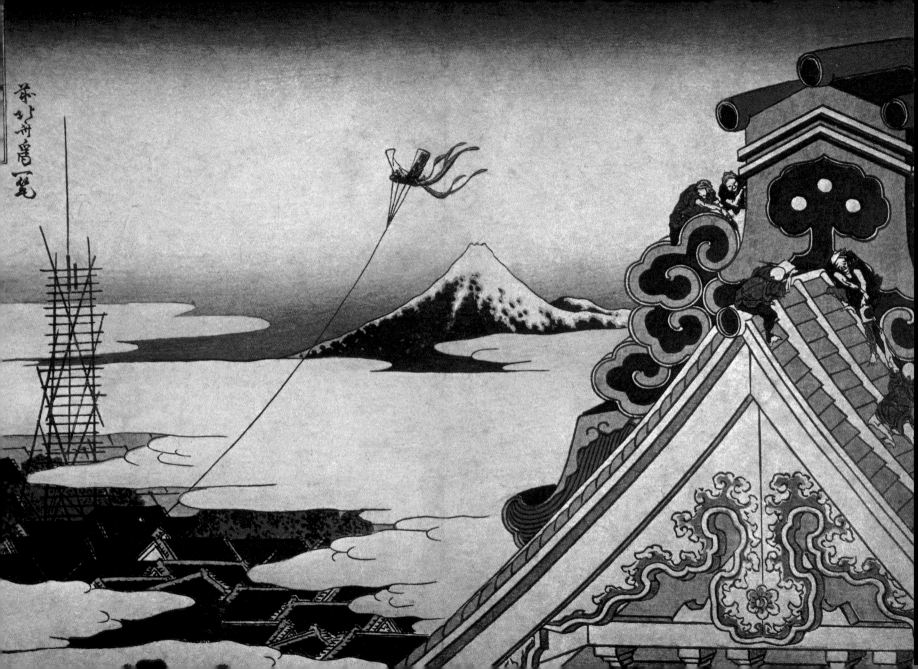

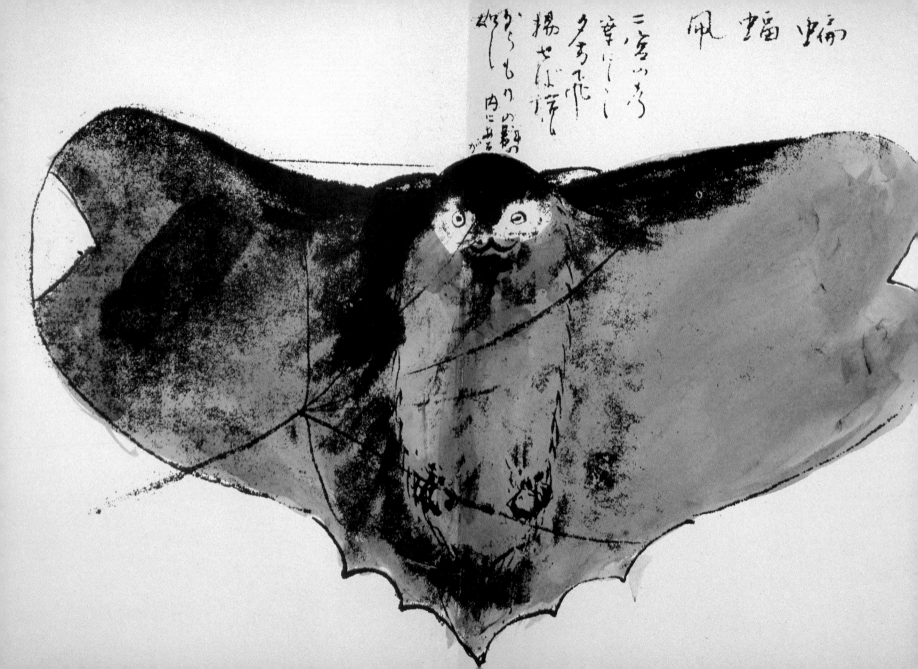

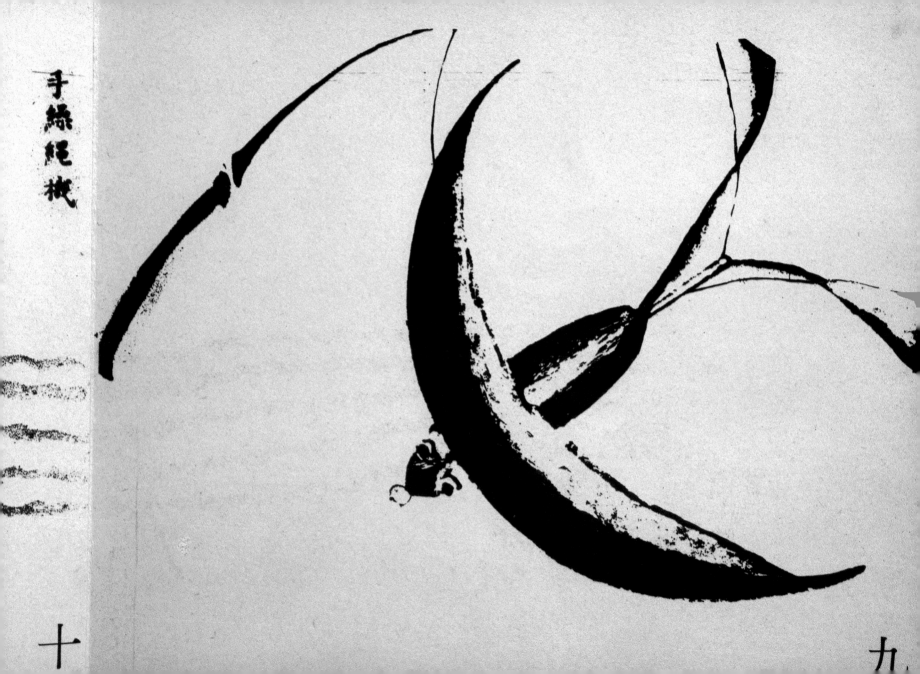

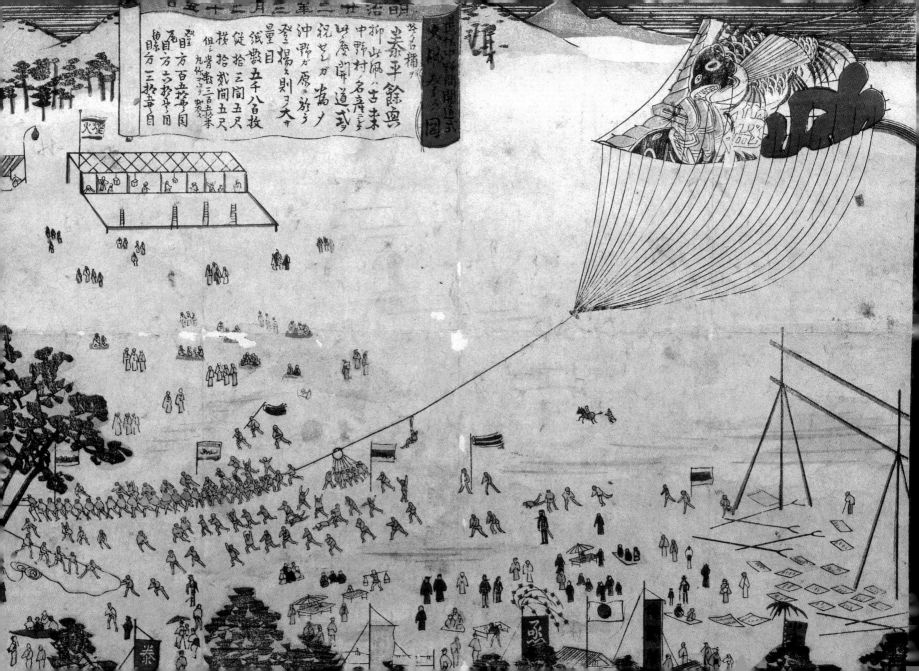

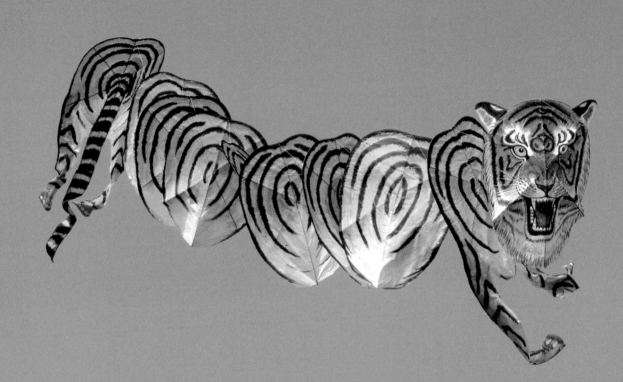

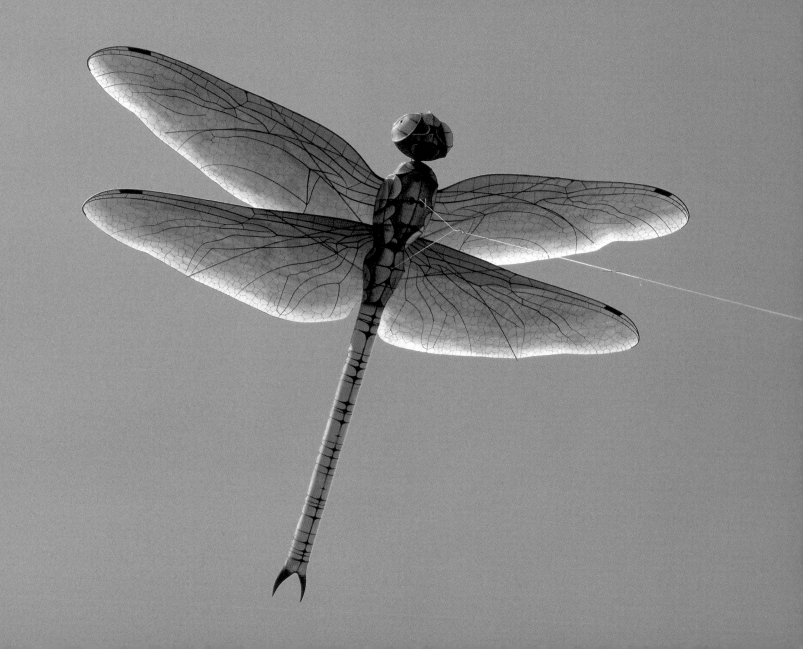

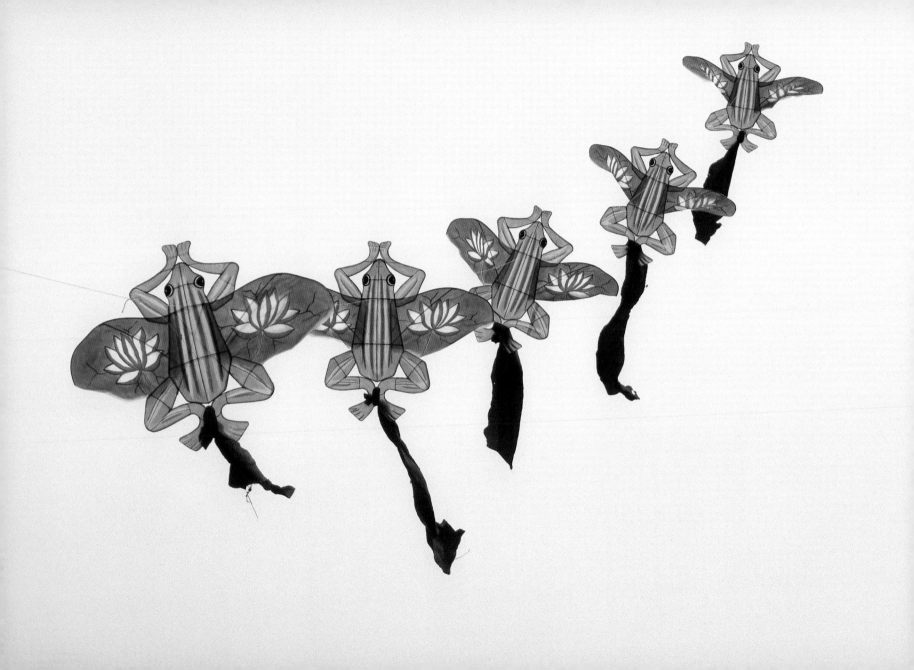

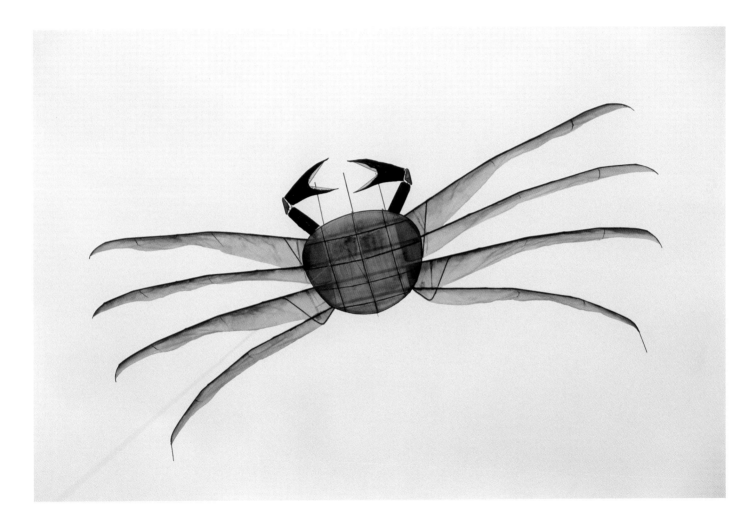

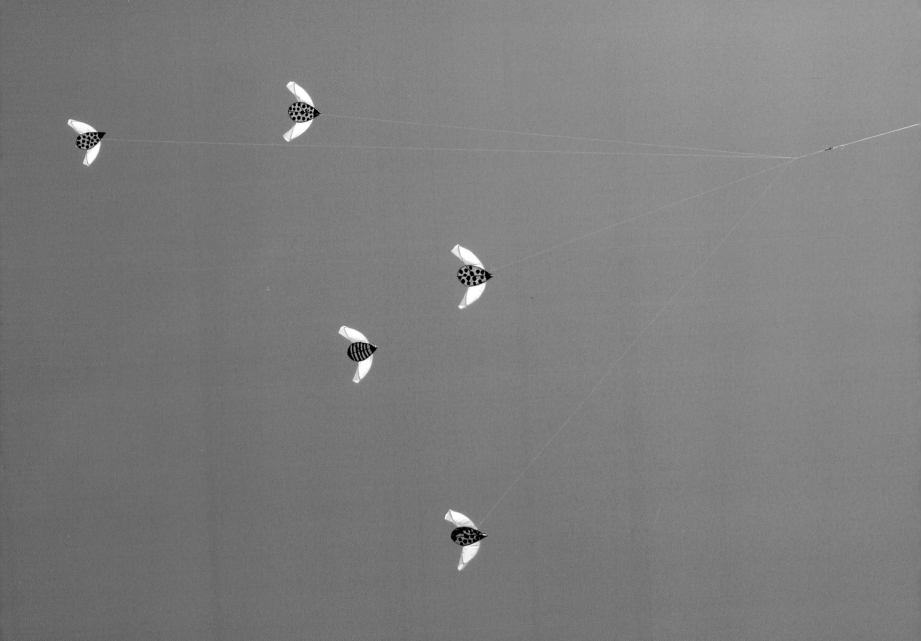

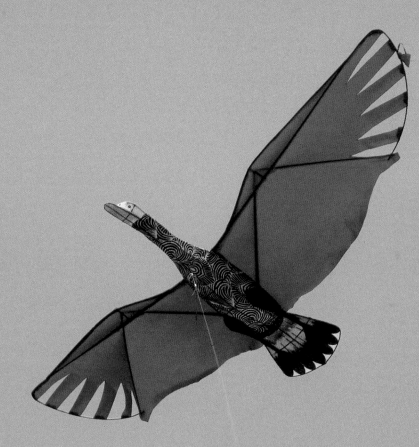

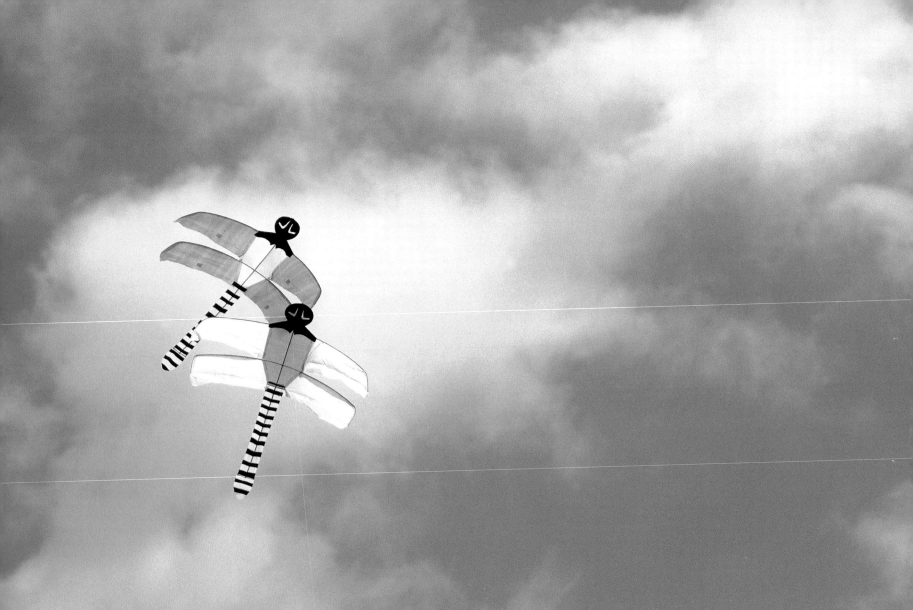

The first kites appeared in China in the fourth century BC.

According to ancient texts, the master Mo Do created a flying wooden replica of a bird of prey, Kite (Milvus), and his disciple Gogshu Baan made a bamboo magpie (Pica) that stayed aloft for three whole days—paper was invented much later. Since these ancient times, the preference given to birds and animals as models has sustained, to a point where the majority of Chinese kites today represent birds, fishes, tigers, insects, and frogs, not to mention beasts from the Zodiac and phoenixes or dragons from Chinese legends. These real and imaginary animals are still omnipresent in Chinese society today and have many symbolic associations. The carp, for example, is a symbol of abundance, the swallow represents conjugal fidelity, and the bat signifies happiness. Kites, emulations of them all, are a part of national heritage and present at every important event in Chinese life. Like the models in nature, kite practices have changed very little: Their function is above all to perpetuate the traditional skills.

Kites are now upholstered in paper or silk and painted with refinement and precision, in absolute harmony with the Chinese attachment to detail, polished to perfection—as shown in the strikingly realistic eagle heads. The techniques used for the frames have remained the same for generations: the bamboo being heated and bent before it is split, then lashed together and glued in place. Most of these creations exhibit an astonishing understanding and mastery of aerodynamic constraints—witness the extraordinary trains of kites that can comprise up to fifty birds all attached to the same cord. They give the illusion of a flock of real birds passing over. Nature has never been so well imitated with paper.

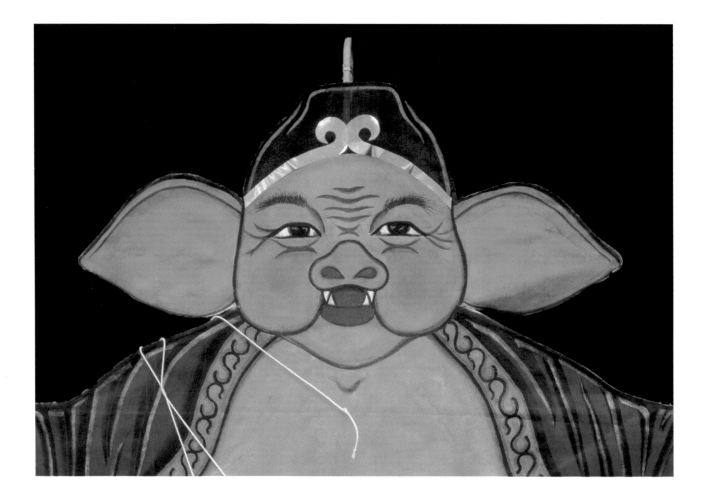

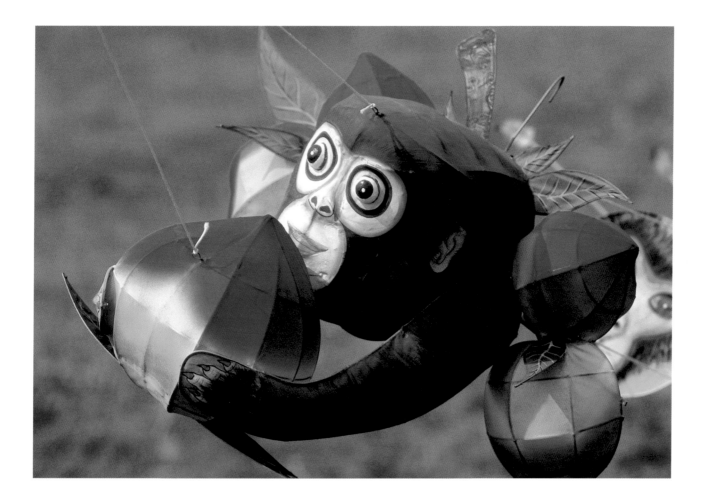

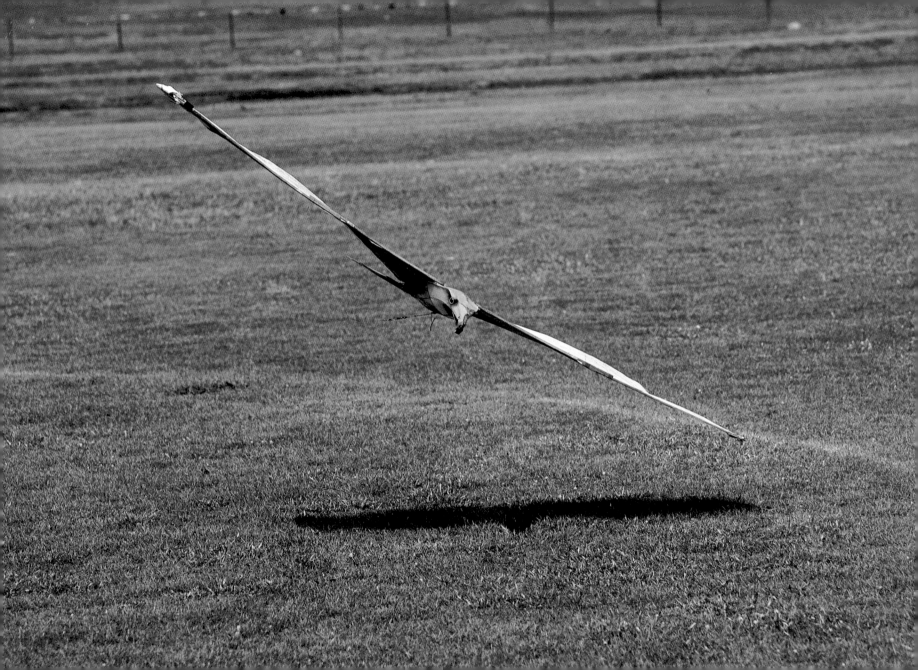

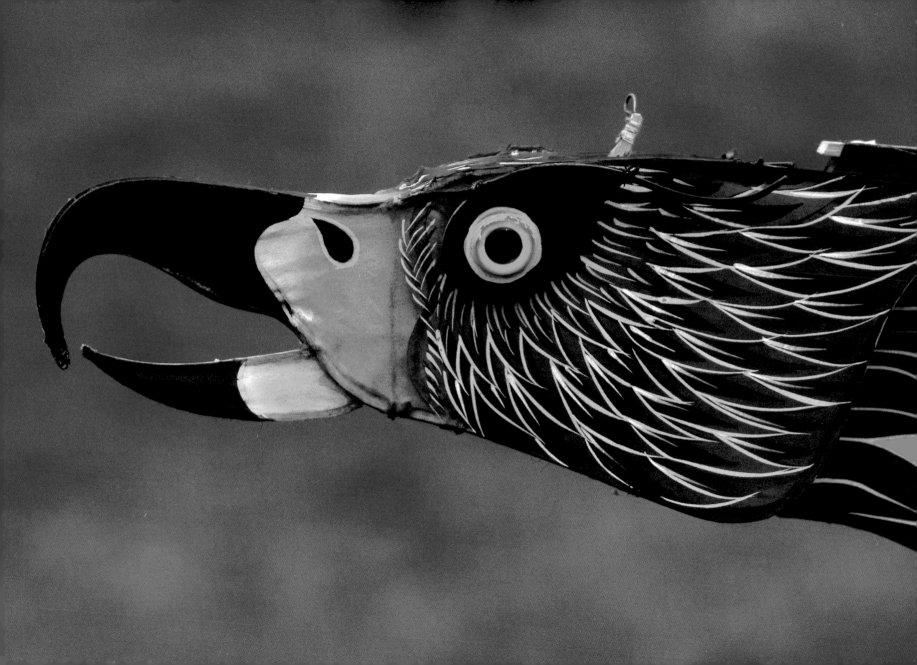

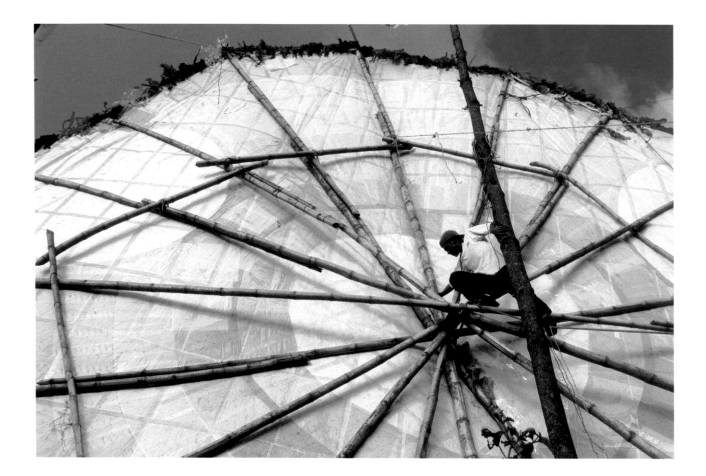

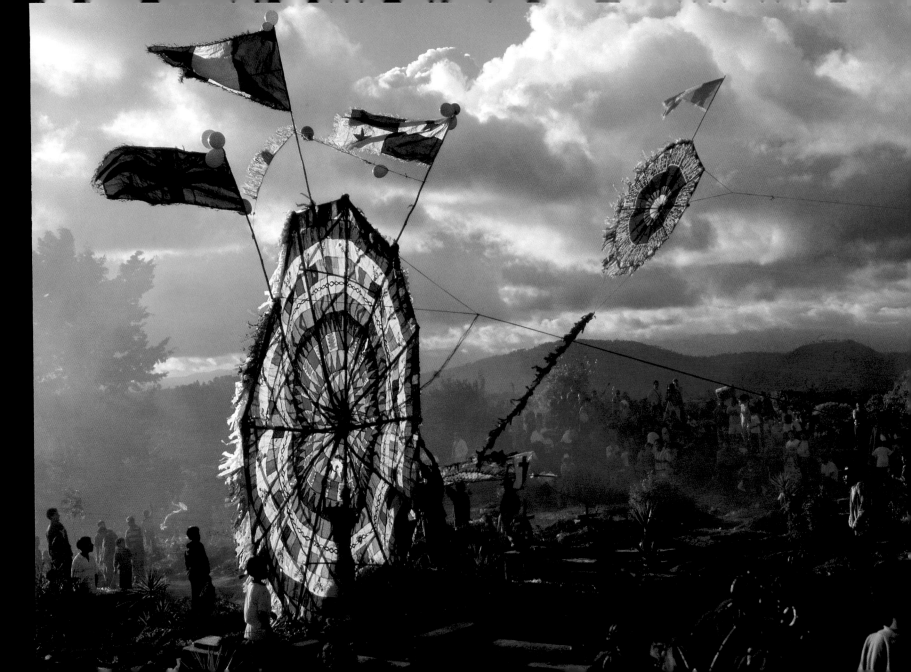

Every year, on the Day of the Dead, families from the villages

of Santiago Sacatepéquez and Sumpango, Guatemala, convene in the local cemetery to fly enormous round kites (barriletes) in homage to their ancestors. The legend is that any soul still embedded in the earth can on that day follow the kite cords and float away into the sky.

These special kites, whose diameter varies between six and twenty-one feet (two to seven meters), are the exclusive undertakings of local males, who make them in strict secrecy. The making of the kites' coverings is a long, complicated process, involving brightly colored tissue paper cut into triangles and laid in concentric circles, then stuck onto plain white paper. It takes about a month and the result is very impressive. The finished kites, fixed to a star-shaped frame made of cane and bamboo rods, look like an immense stained-glass rose window. The scenes represented in the medallions, which celebrate different aspects of the Maya civilization, give the Cakchiquel Indians a chance to reaffirm an identity that has been consistently repressed during five centuries of foreign domination. On the Day of the Dead, the *barriletes* are flown above the tombs and graves in a carnival atmosphere including the entire village community. Yelling children run around the cemetery. Everybody is visibly happy, momentarily forgetting the hardship of peasant living on an ungrateful soil. Later, at dusk, the men are gripped by a sudden paroxysm of violence, smashing the objects they have so lovingly created. All of a sudden they turn on the majestic sun-shaped kites, crush them, rip them to shreds, and then rake them into piles for burning. Above the flames, tiny blackened flakes go twirling into the sky in a final, melancholy offering to spirits released into a night of perpetual peace.

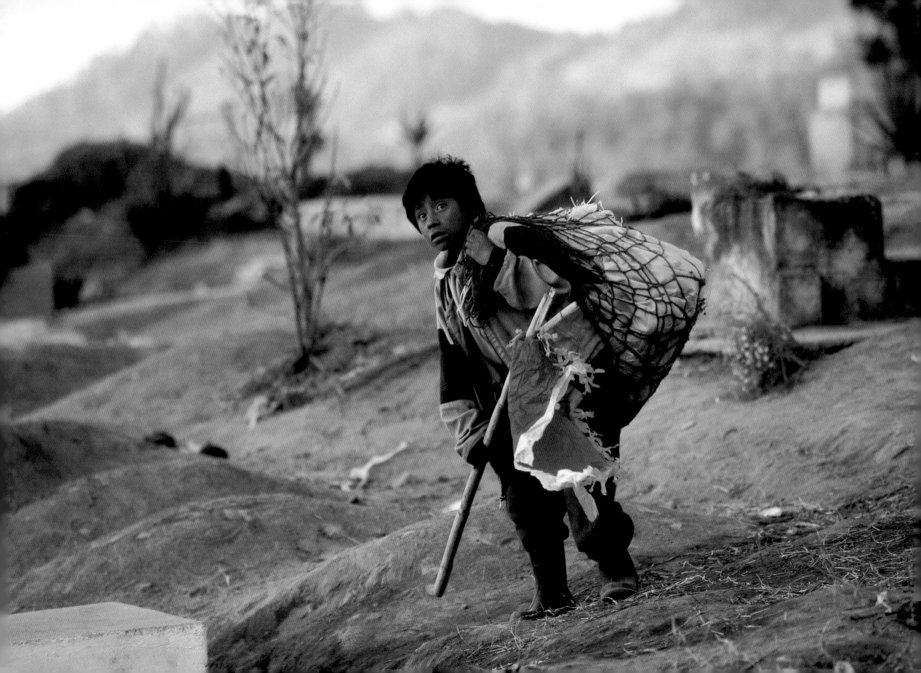

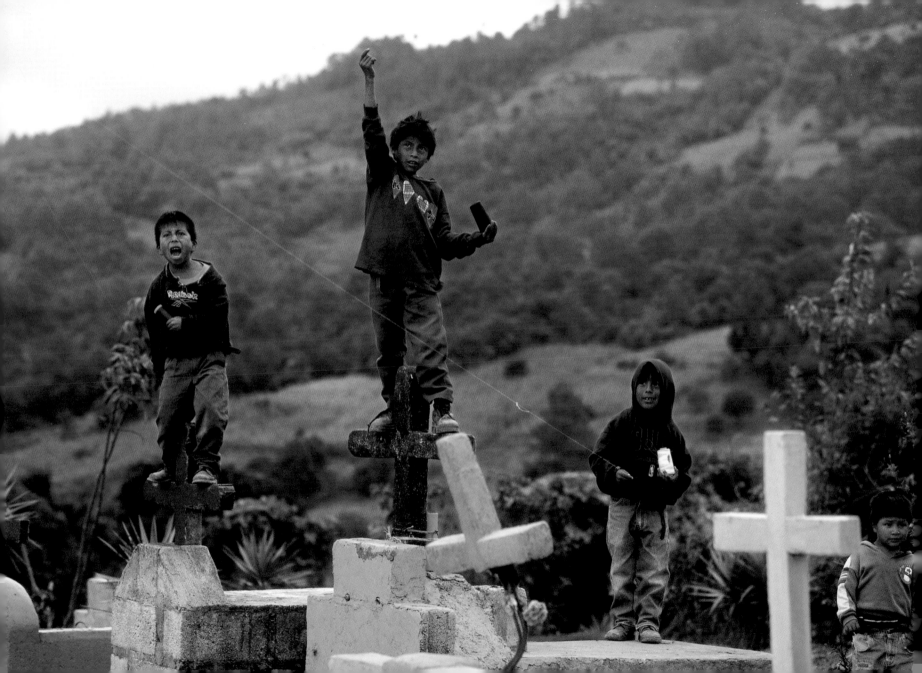

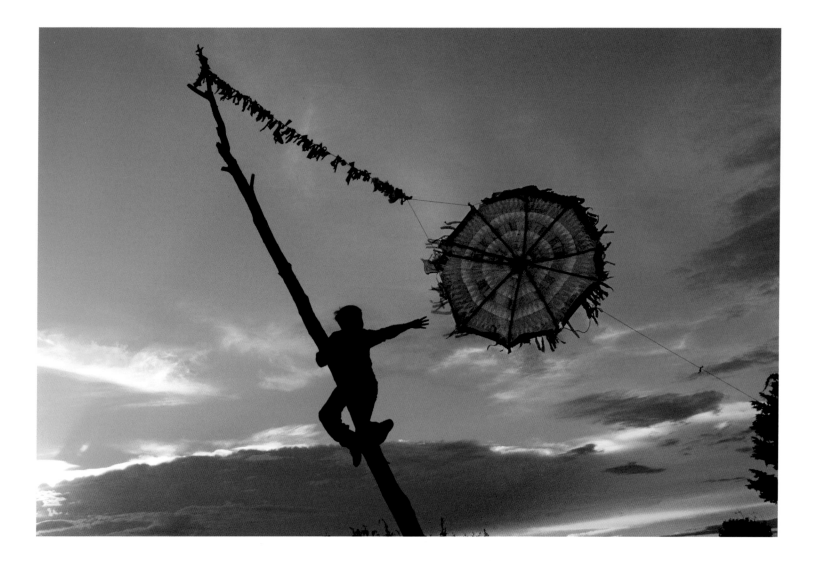

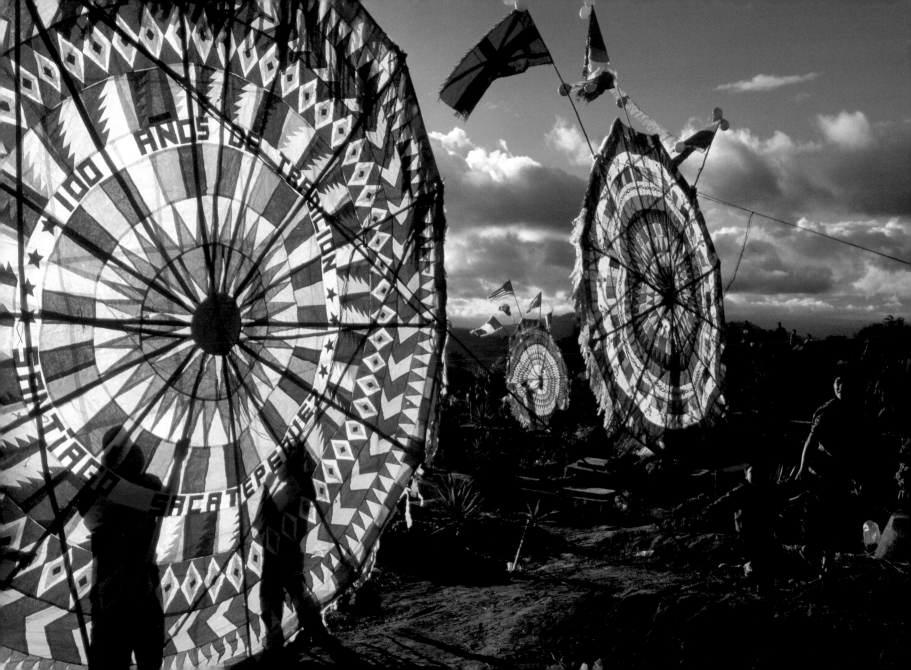

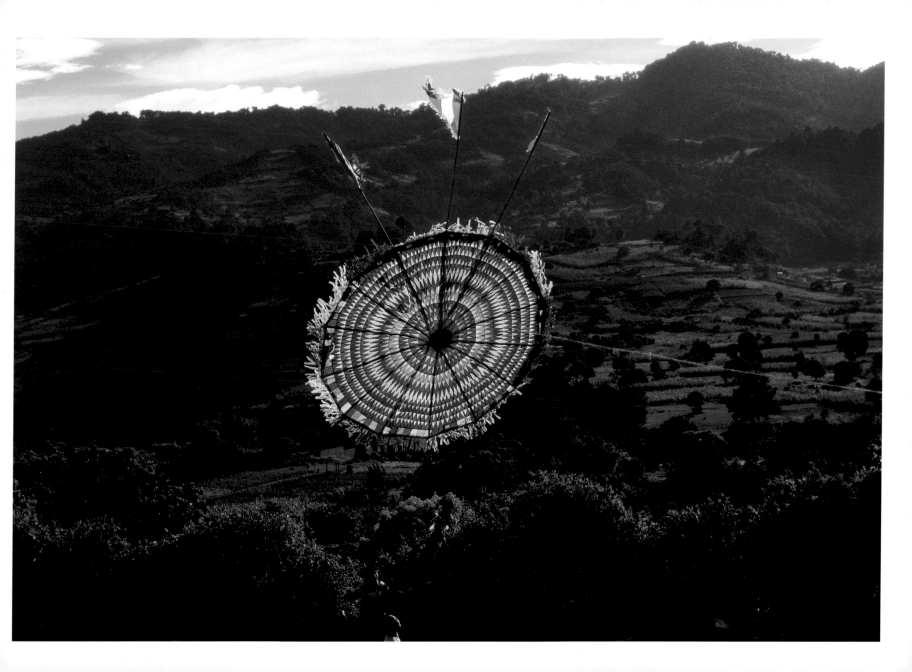

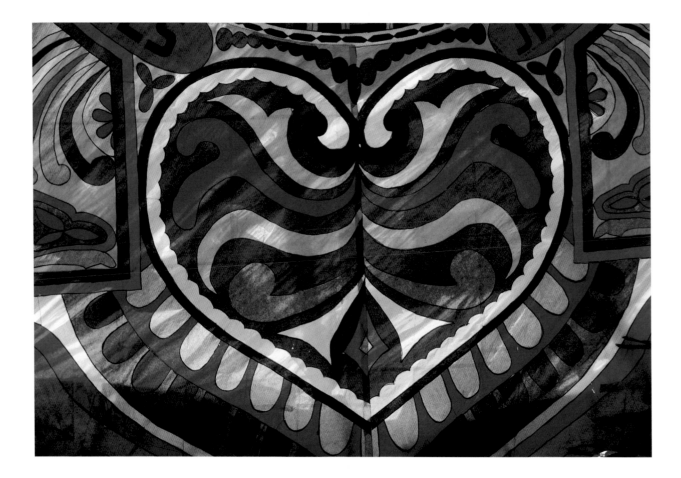

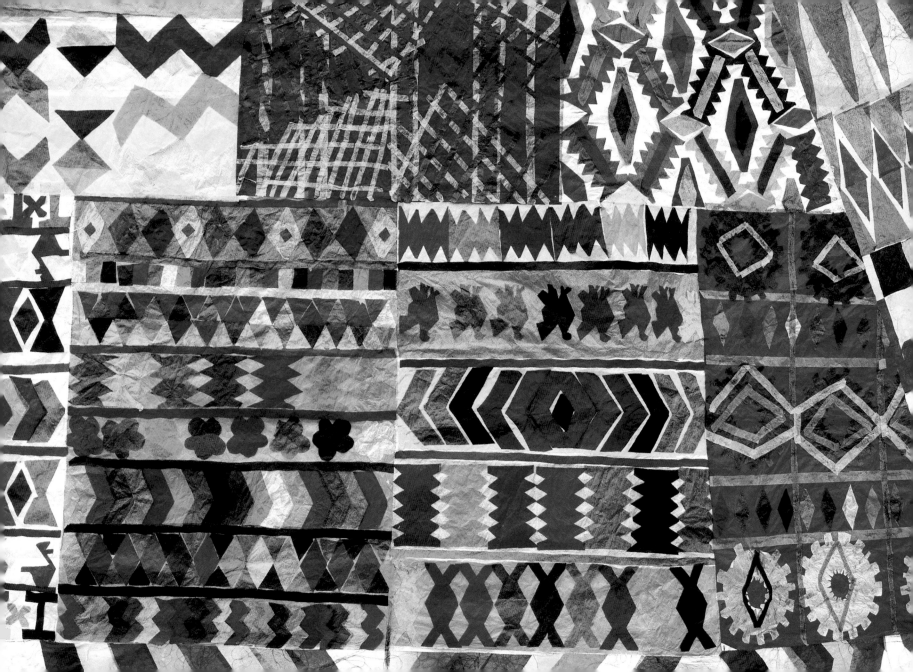

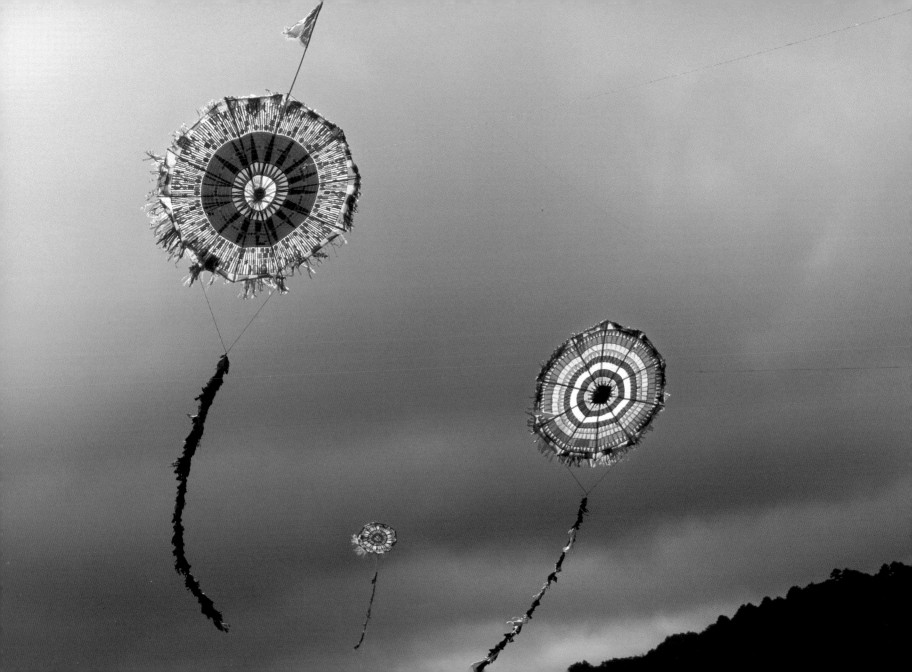

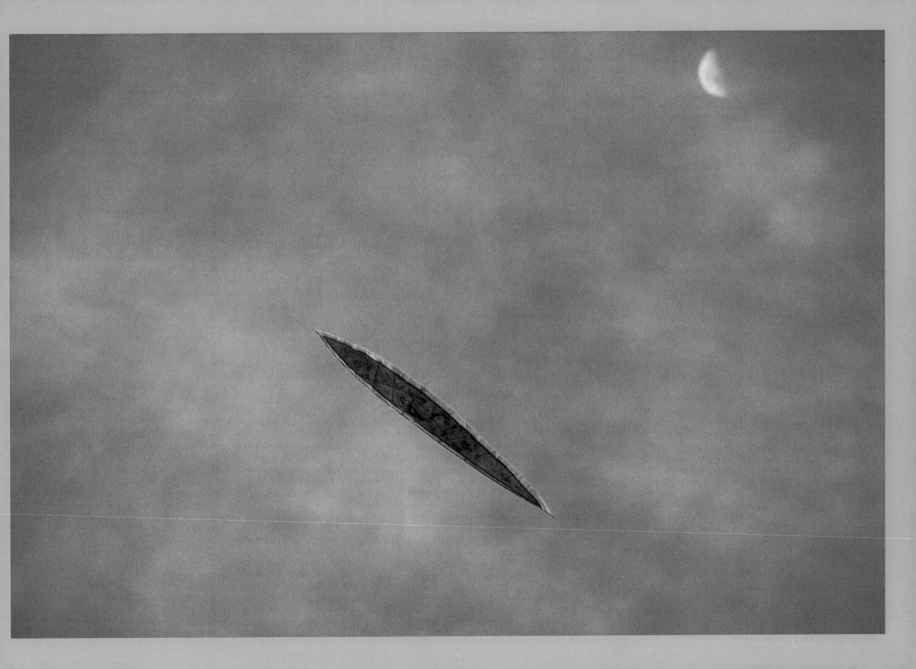

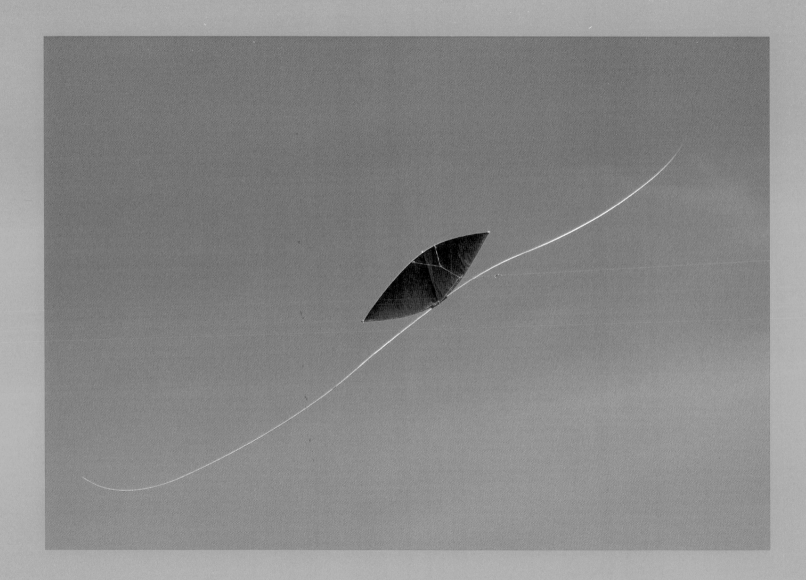

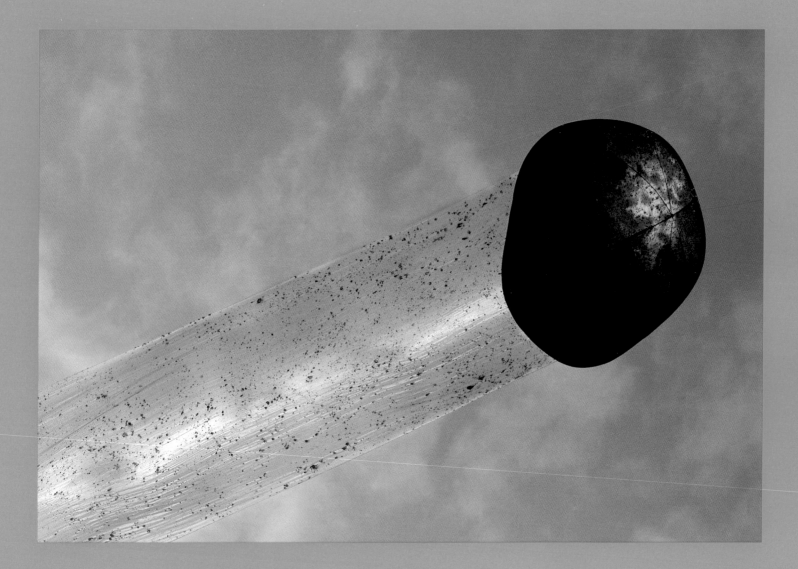

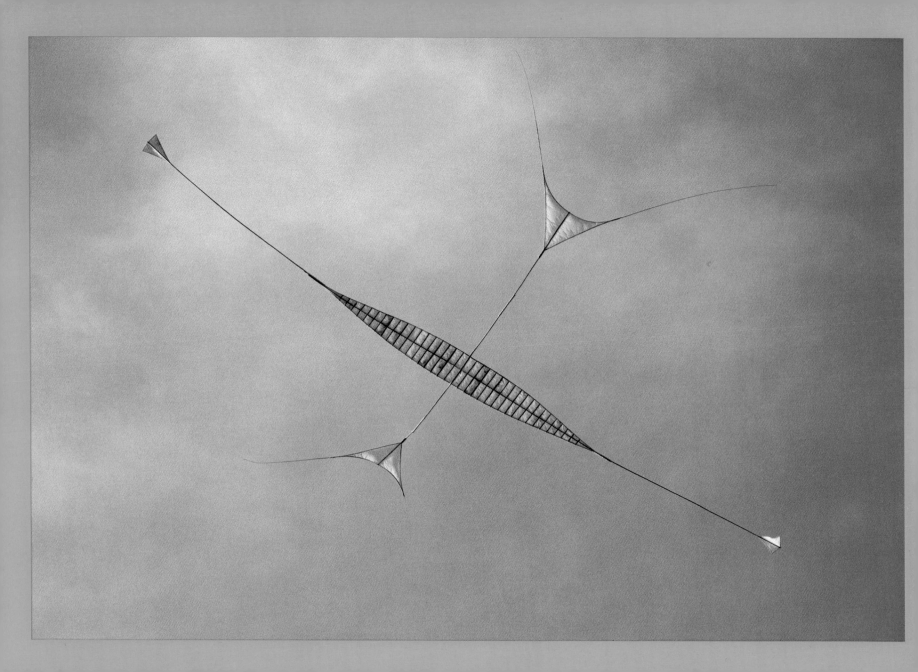

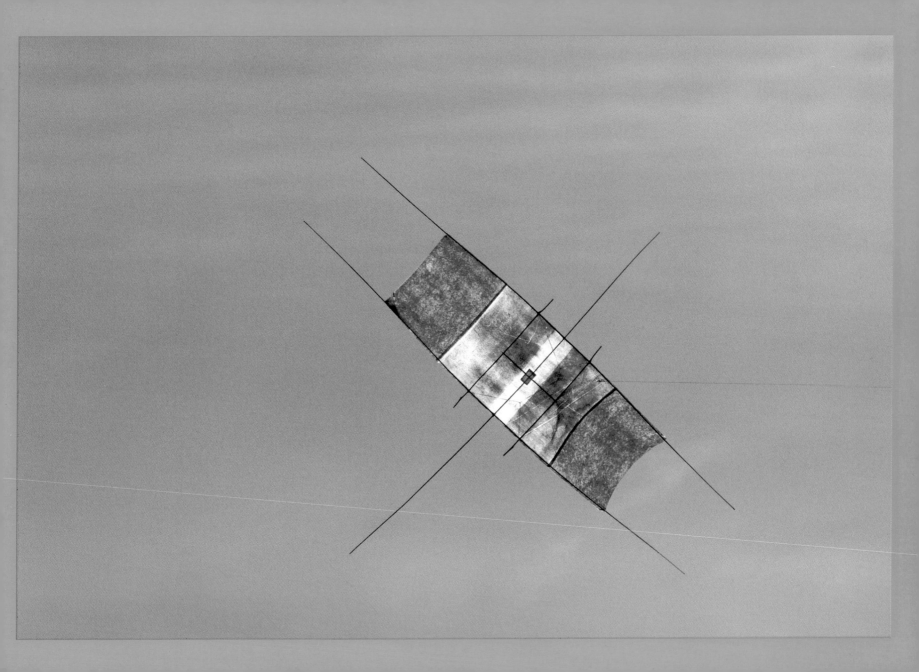

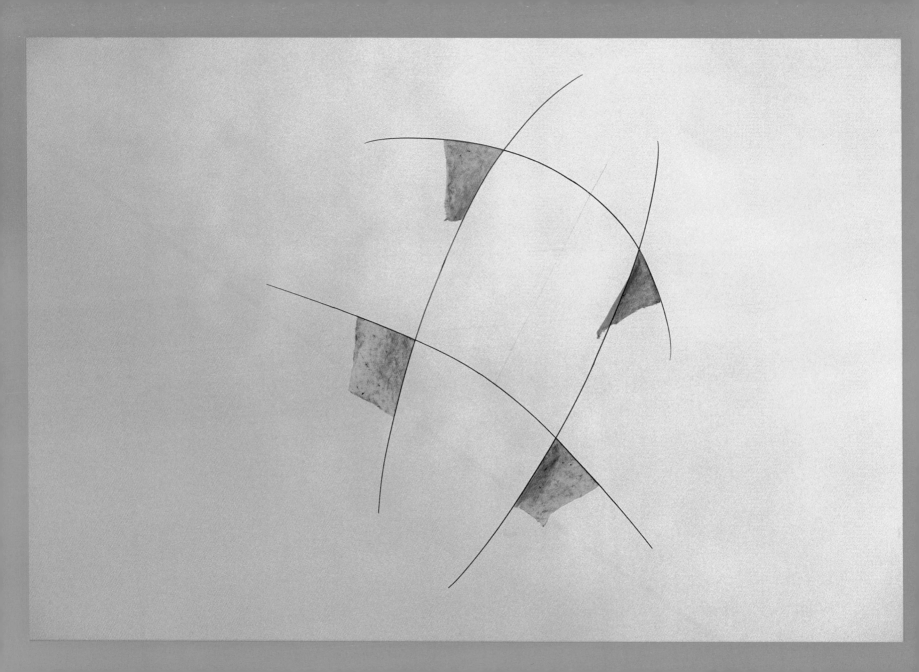

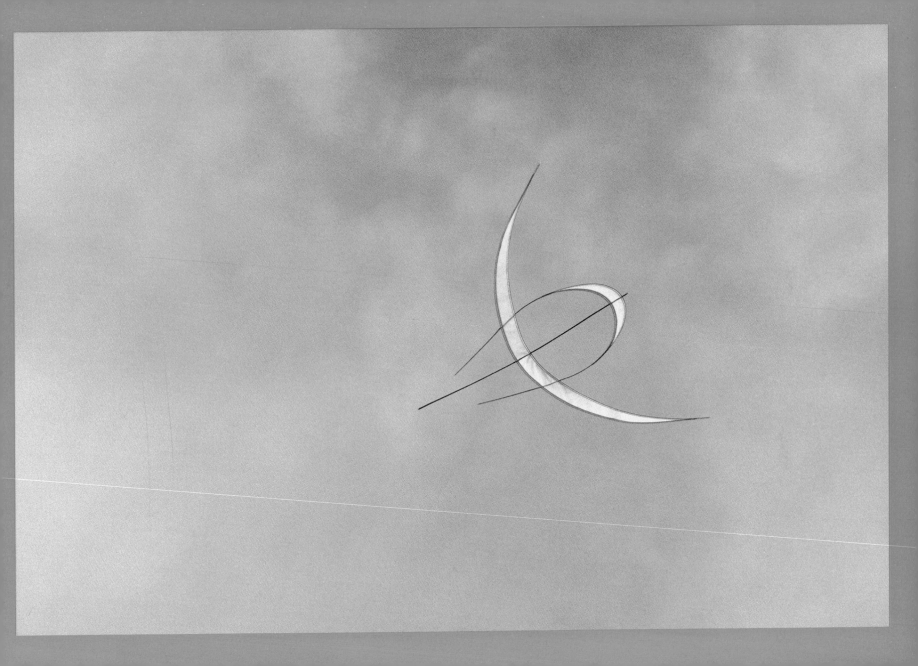

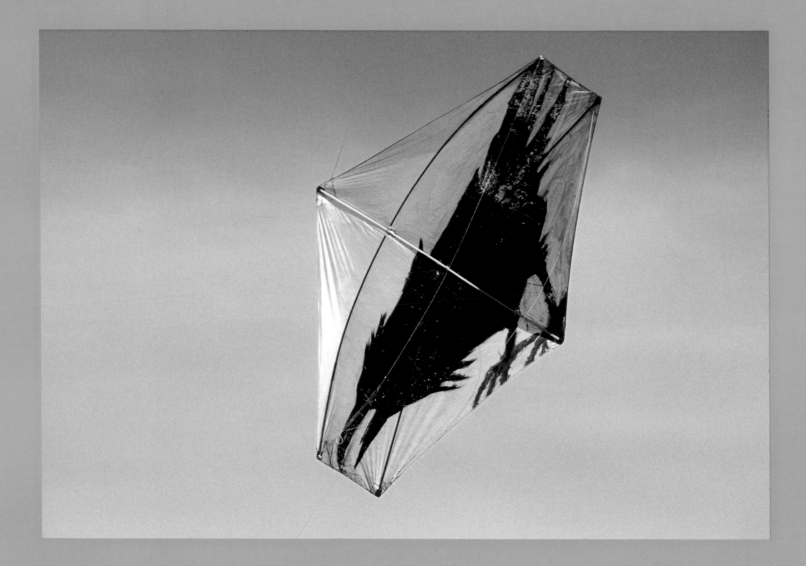

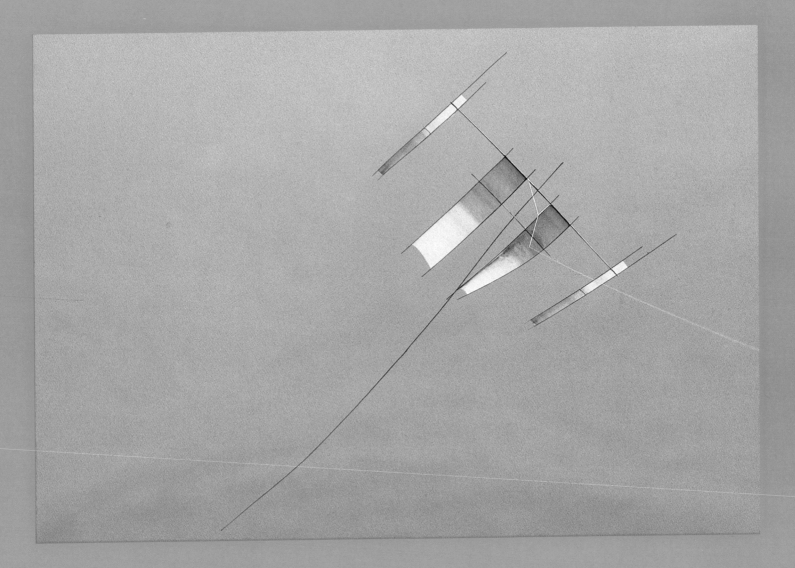

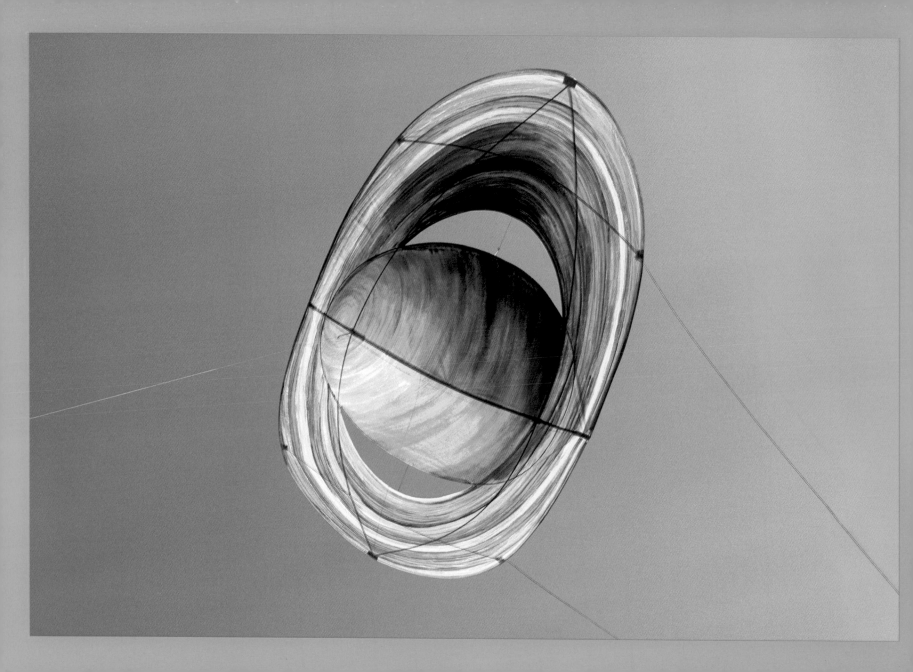

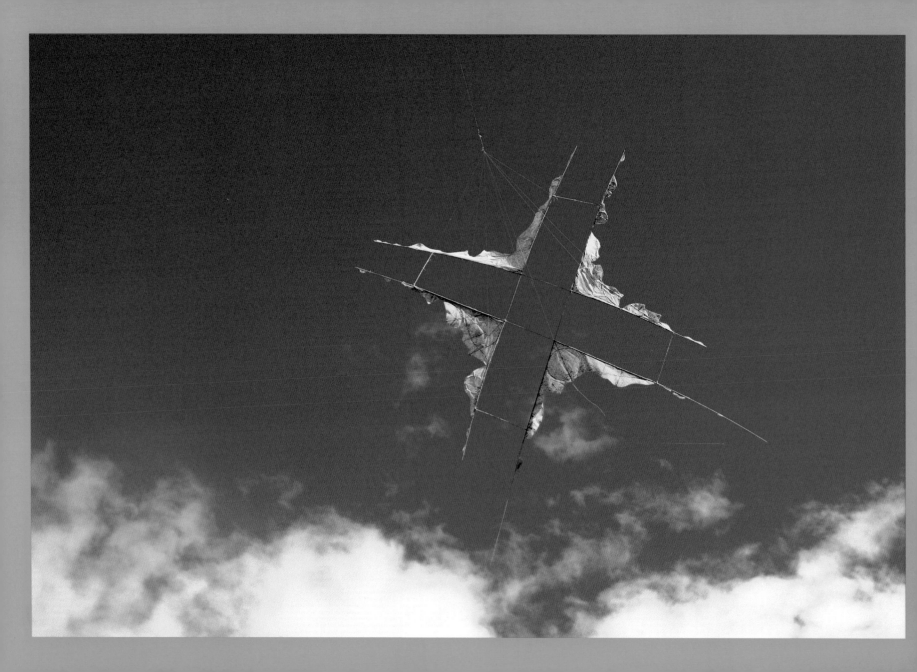

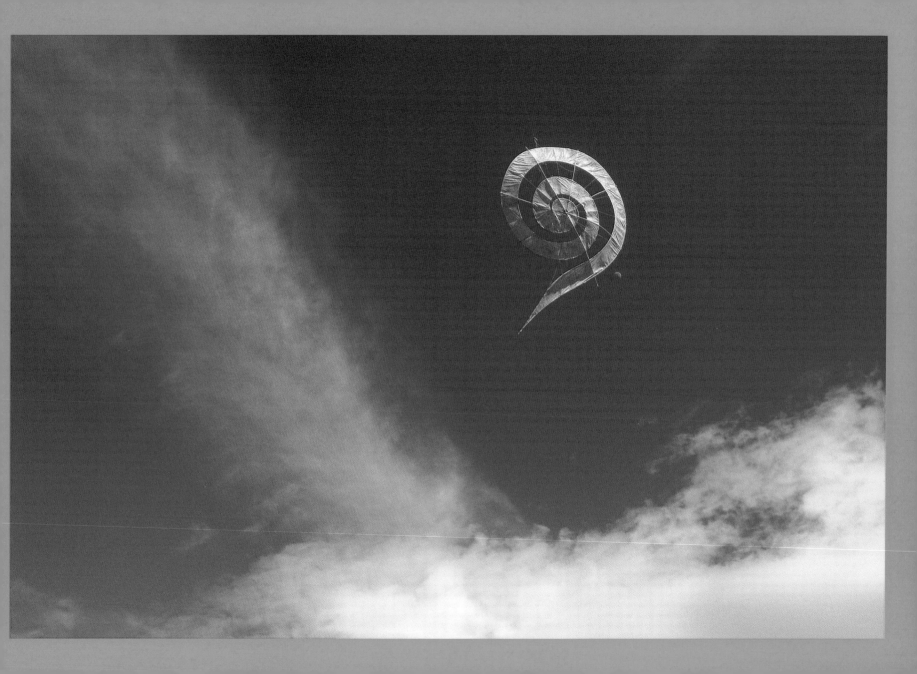

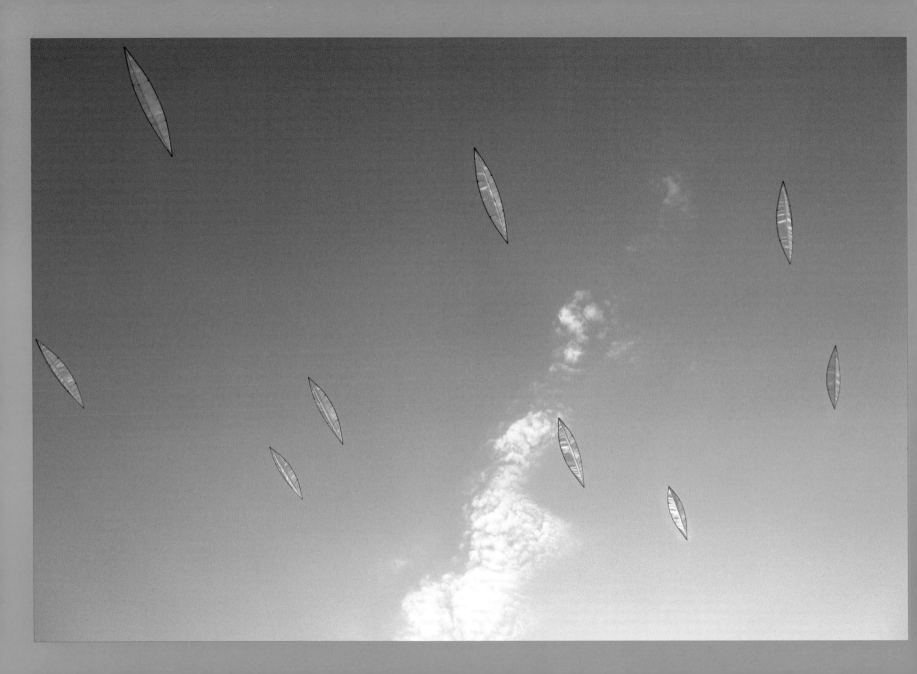

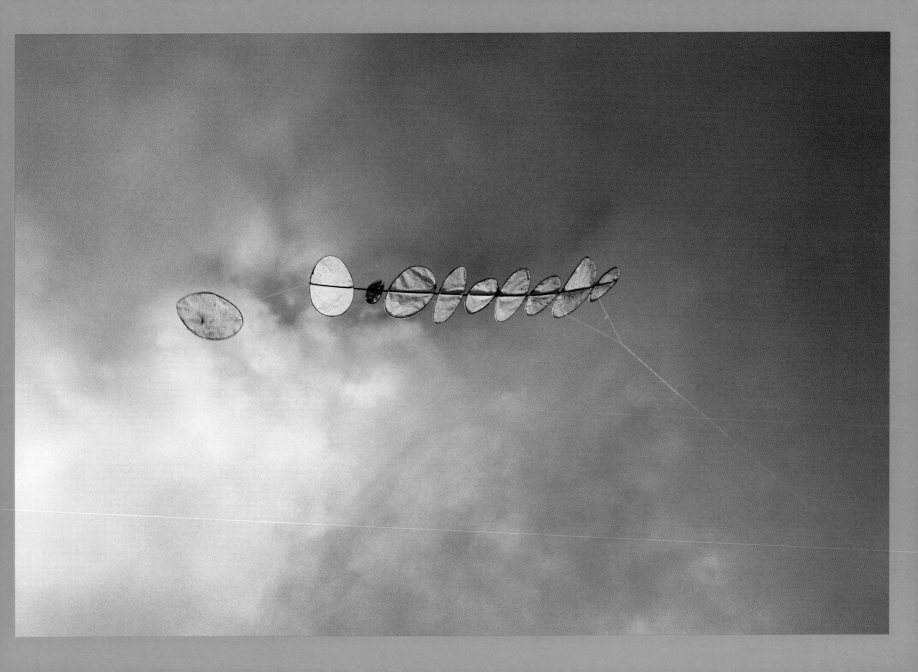

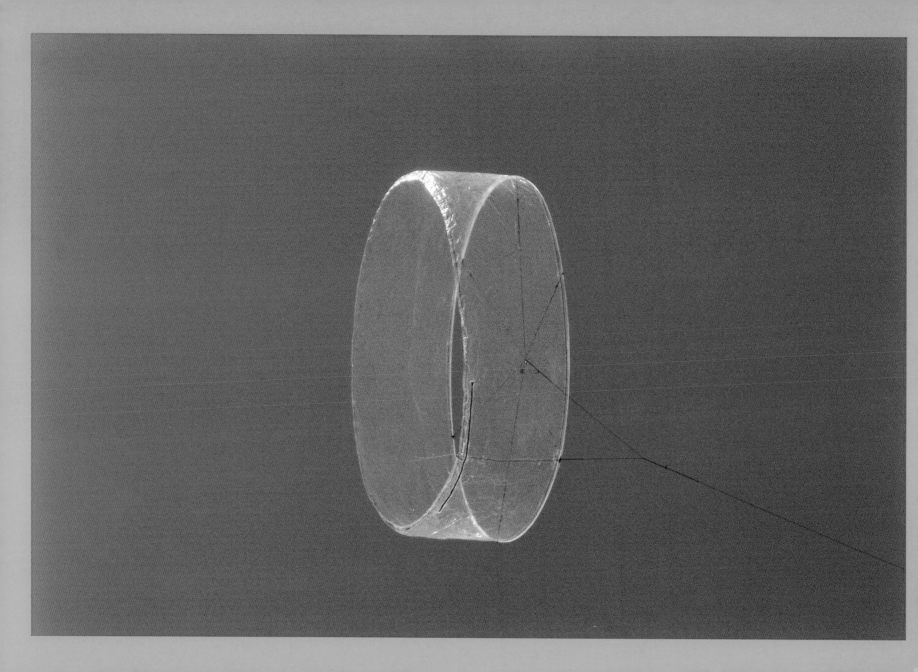

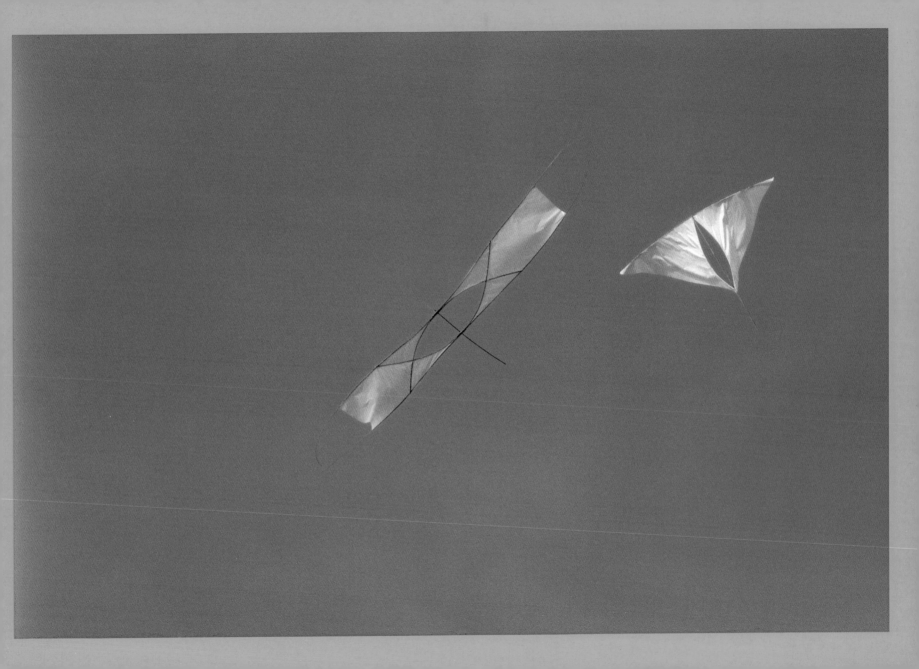

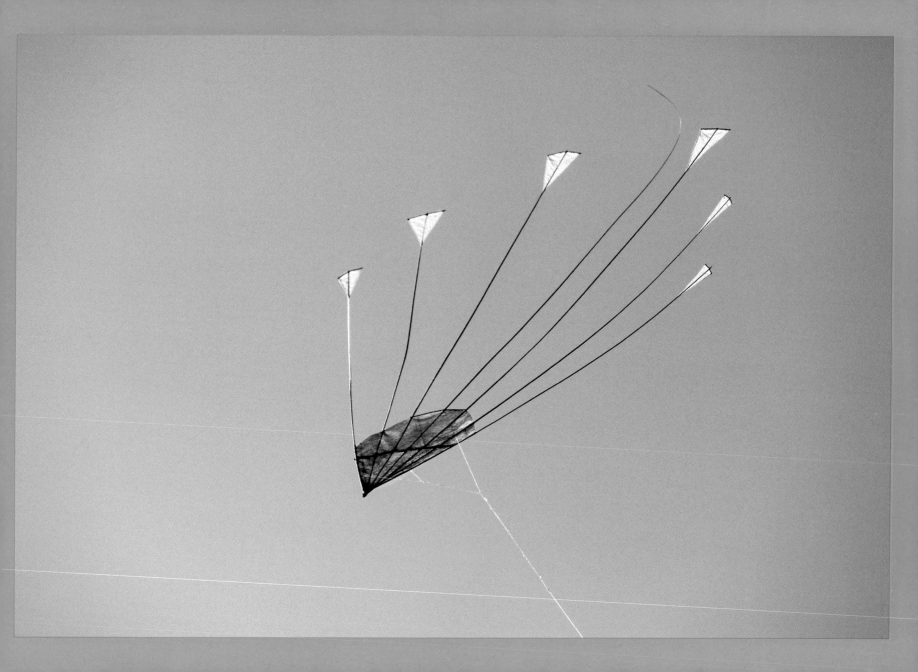

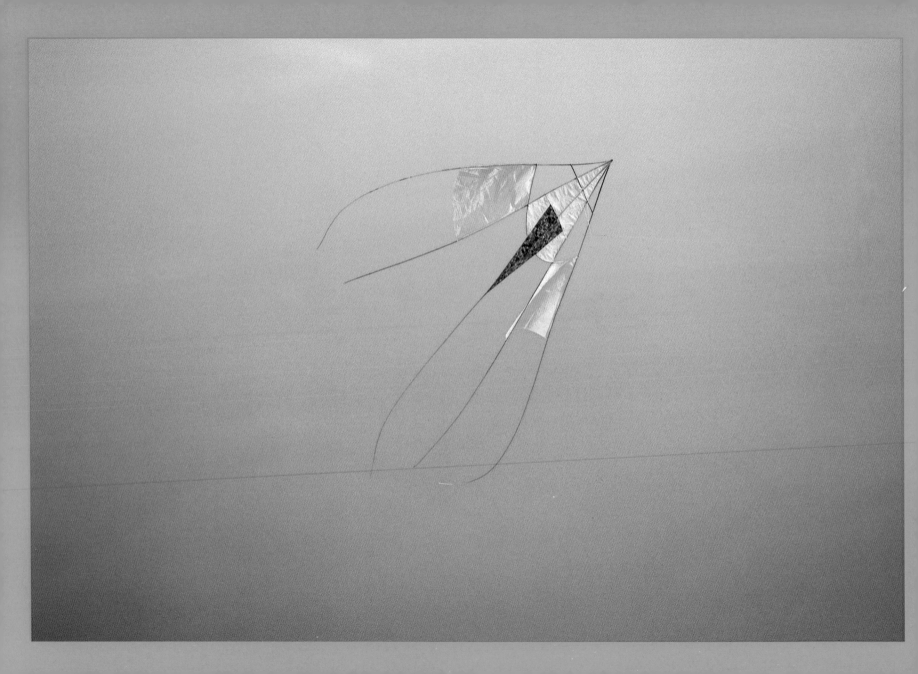

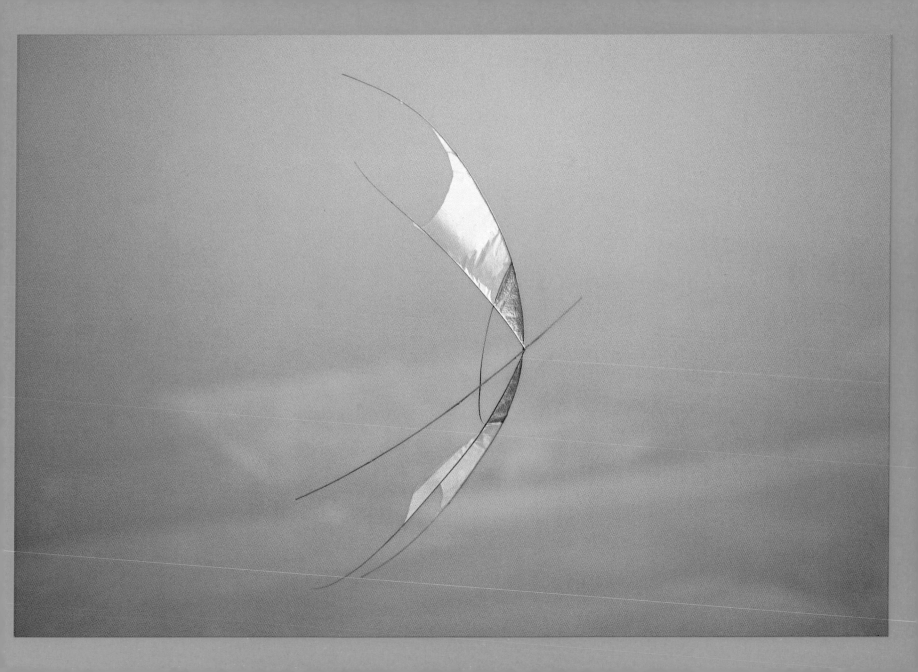

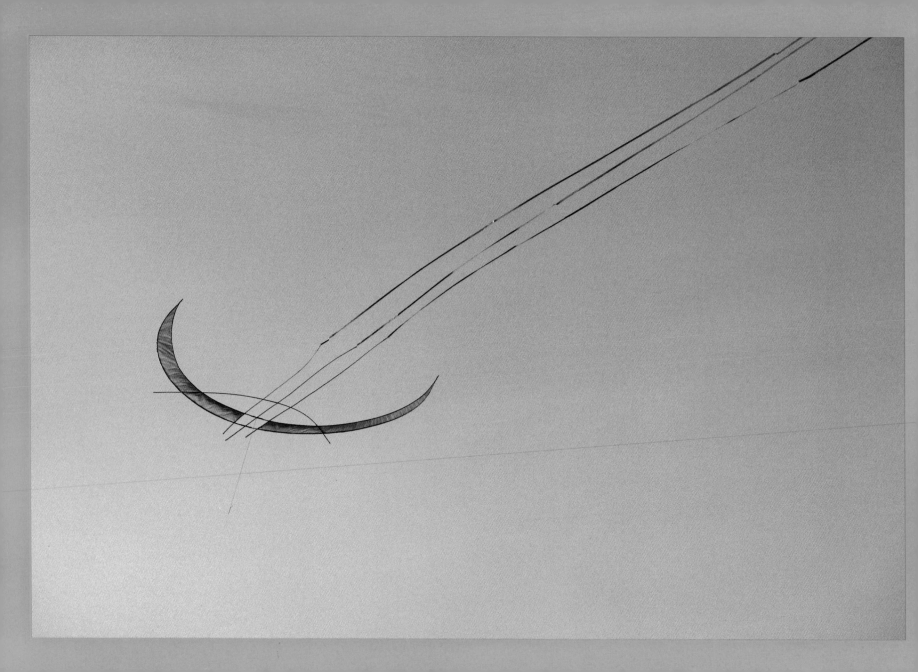

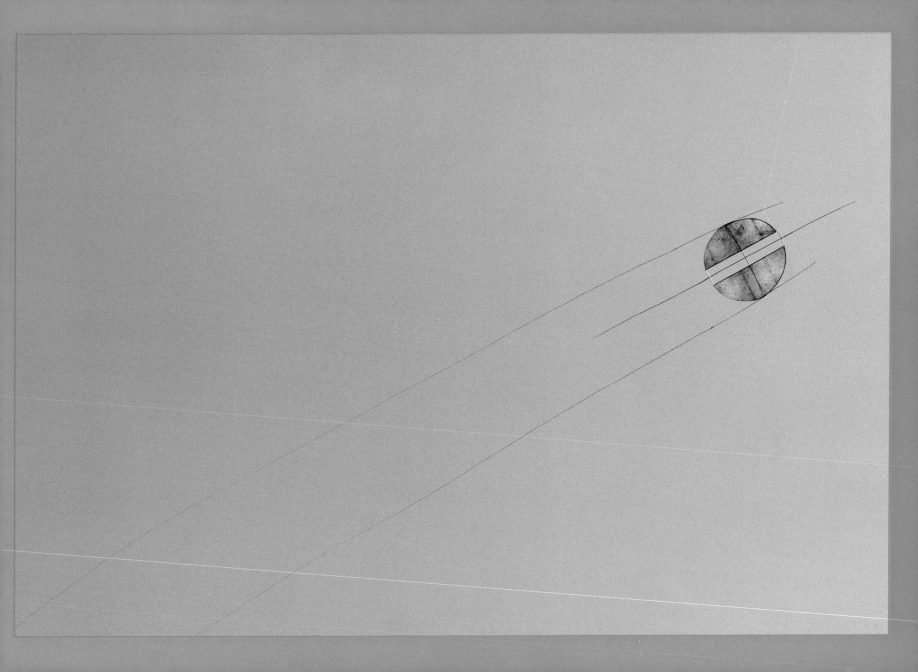

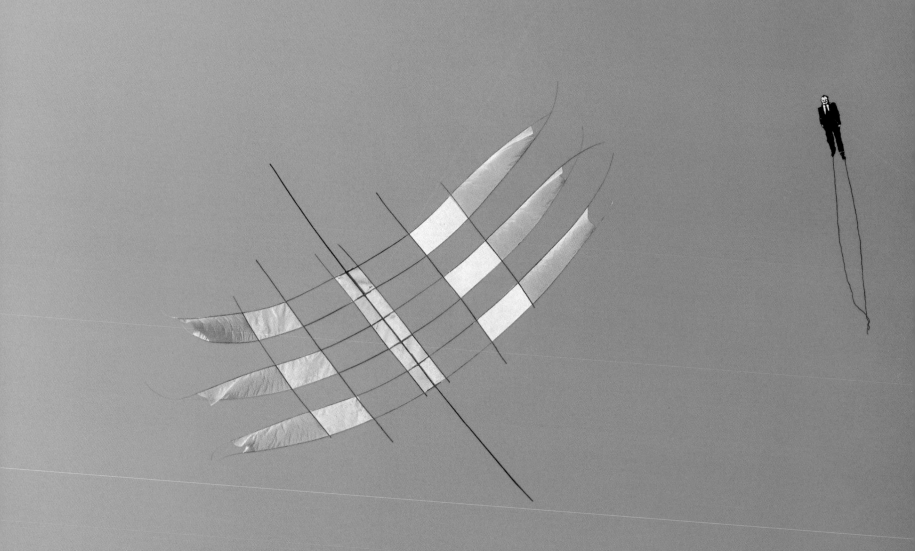

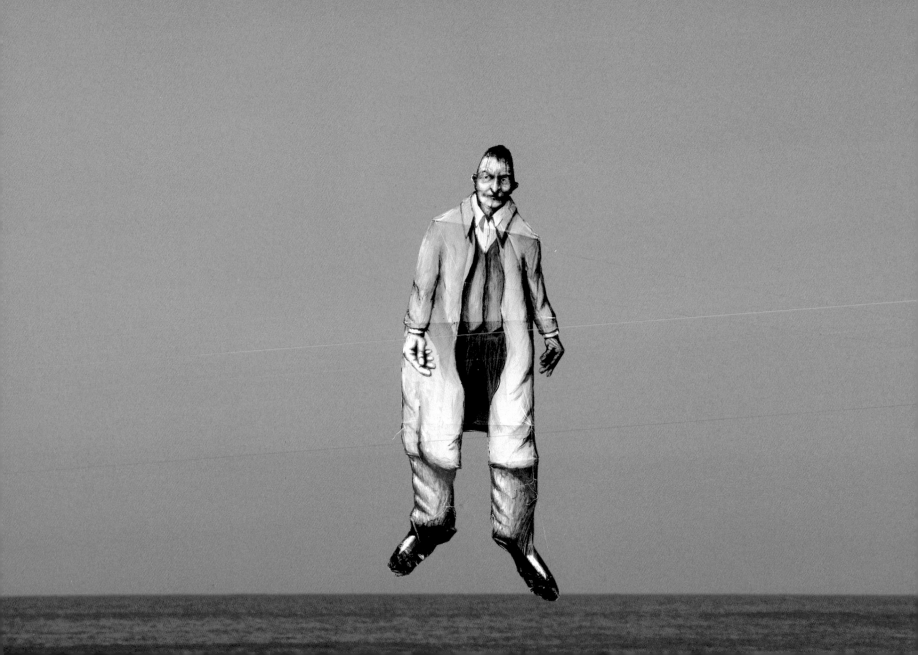

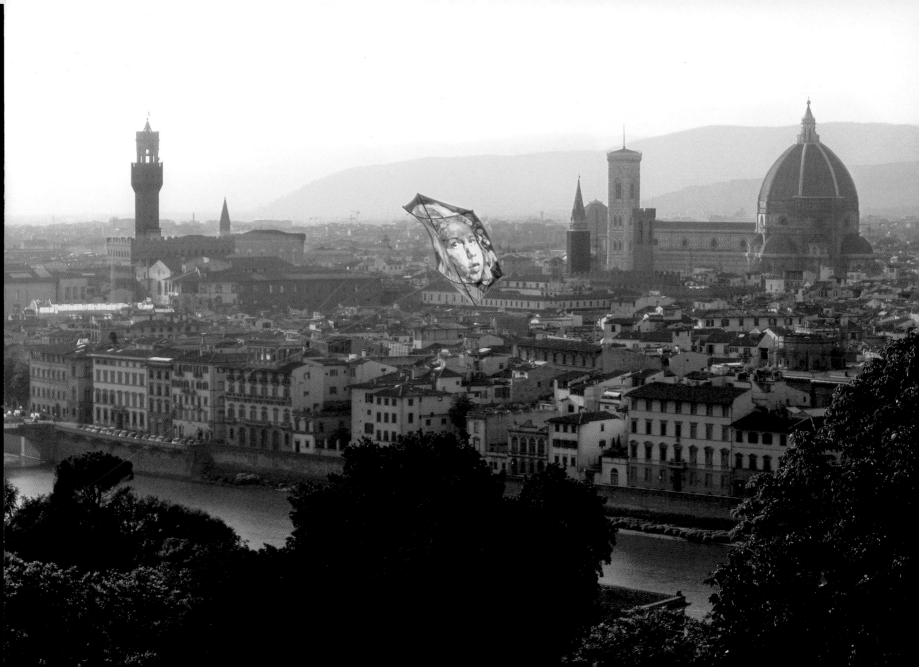

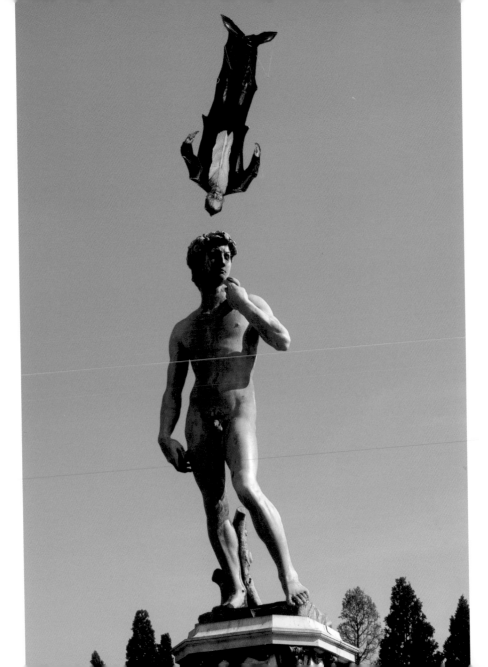

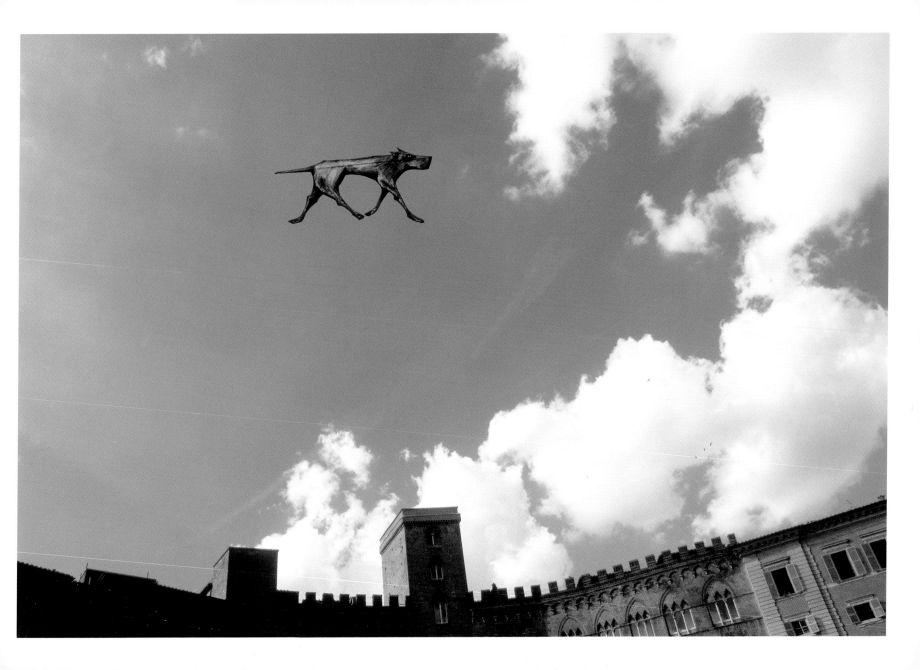

In the splendid Tuscan countryside three friends spent a week doing what they love best—flying their kites. They are no ordinary enthusiasts, however, and their art is not iconoclastic. The paintings of Claudio Capelli floating in the Tuscan sky, the upside-down, elongated figures of Robert Trépanier rippling against marble statues—Michelangelo would have been delighted—and the fragile signs of Philippe Cottenceau high above the Florentine landscape had none of the heresy of Marcel Duchamp's Mona Lisa with mustache and beard entitled L.H.O.O.Q. Indeed nothing in this innocent artistic endeavor was remotely in the nature of a parody. The amused Sienese and Florentine onlookers were aware of it and as they watched the kites swooping above their rooftops, they knew what they were meant to be: a compliment to the beauty of their country. Claudio Capelli, who masterminded the whole event, wants kite-flying to be an act of celebration. By way of contemplating a kite dancing in the wind, Capelli set out to celebrate not only Earth, light, beauty, imagination, and life, but also the countryside surrounding men and the monuments built by men. If Earth must hang by a thread, then let that thread be attached to a kite, for its tenuousness cuts through all heaviness, all gravity.

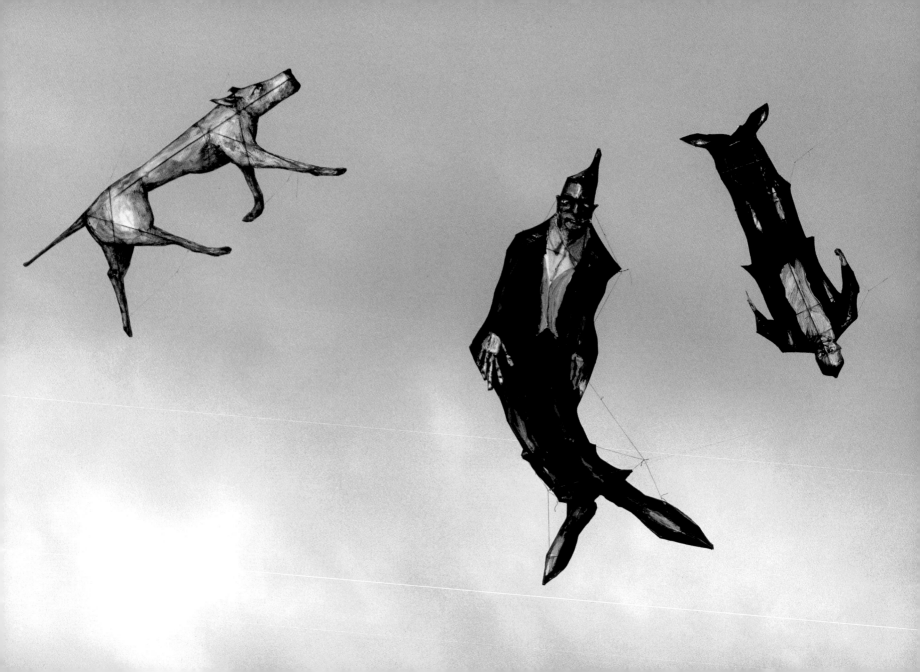

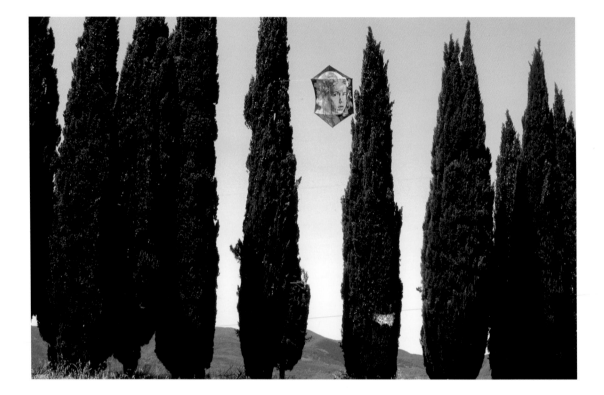

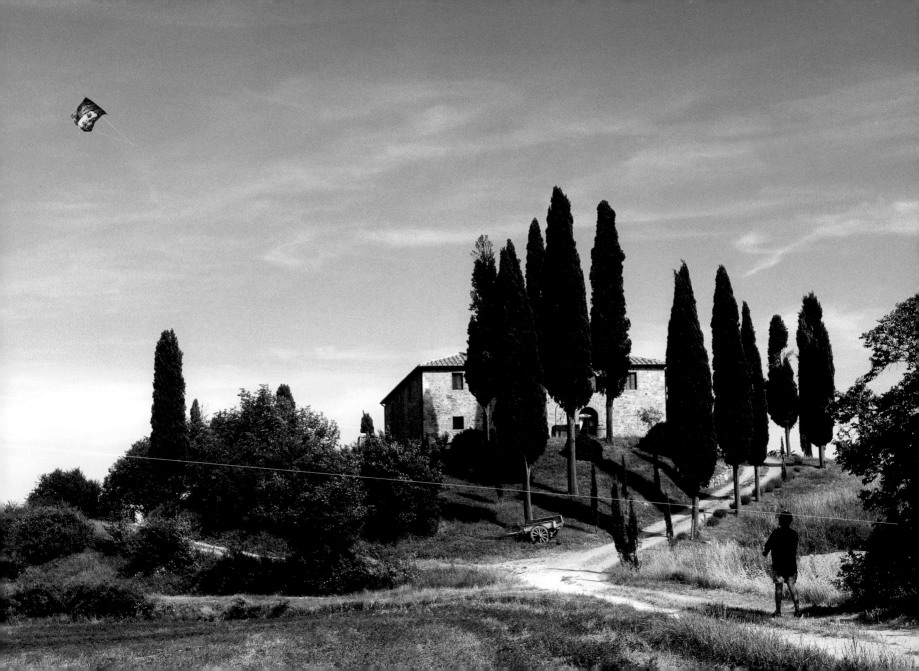

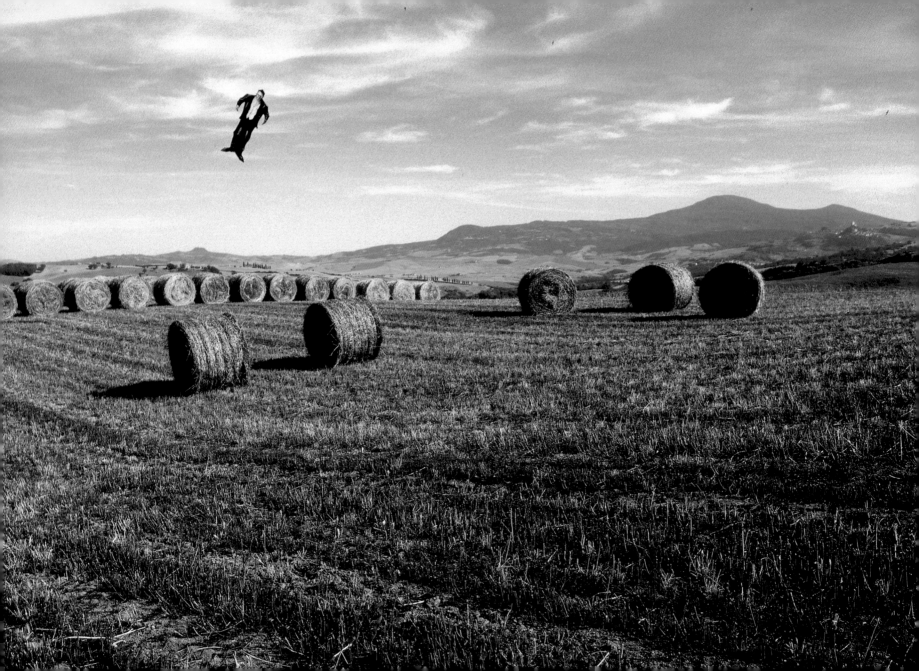

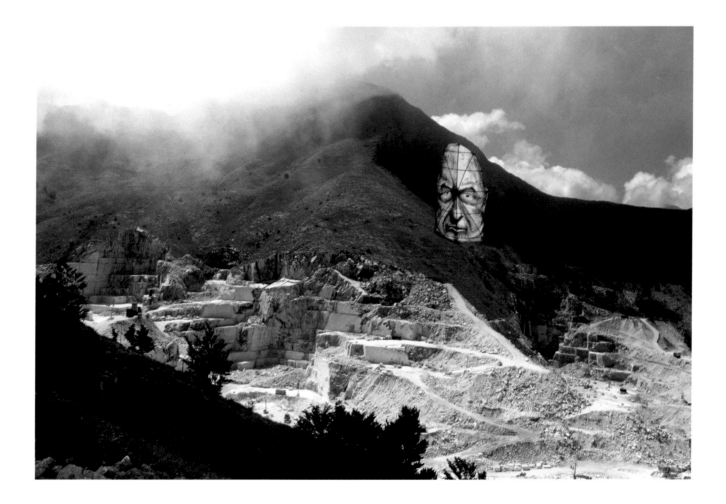

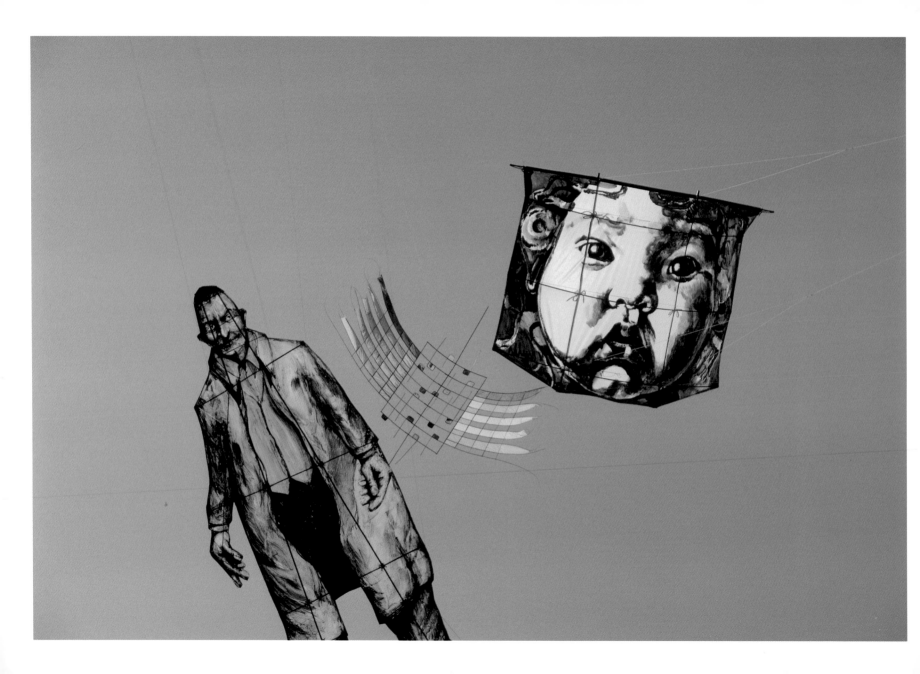

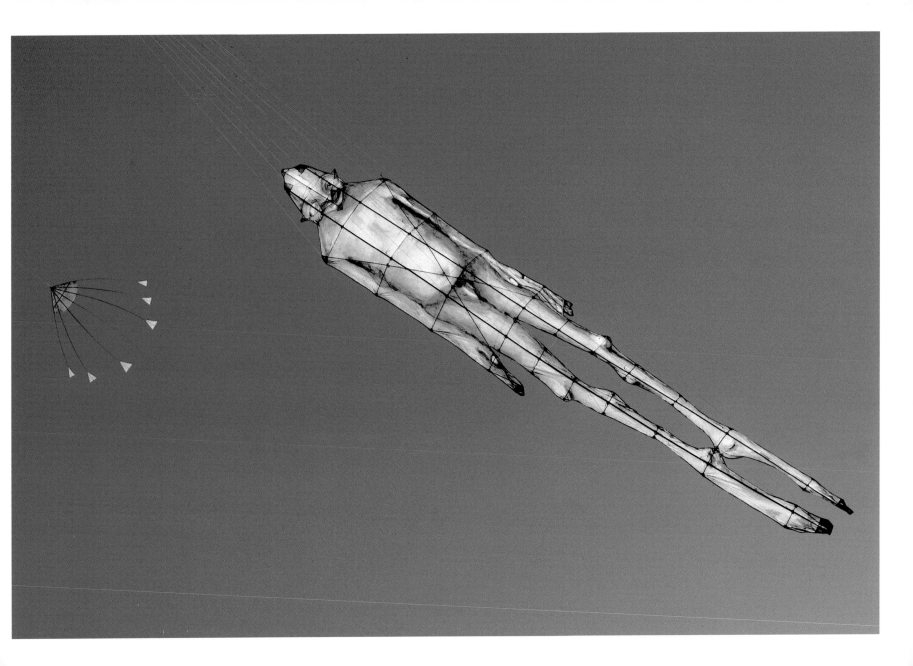

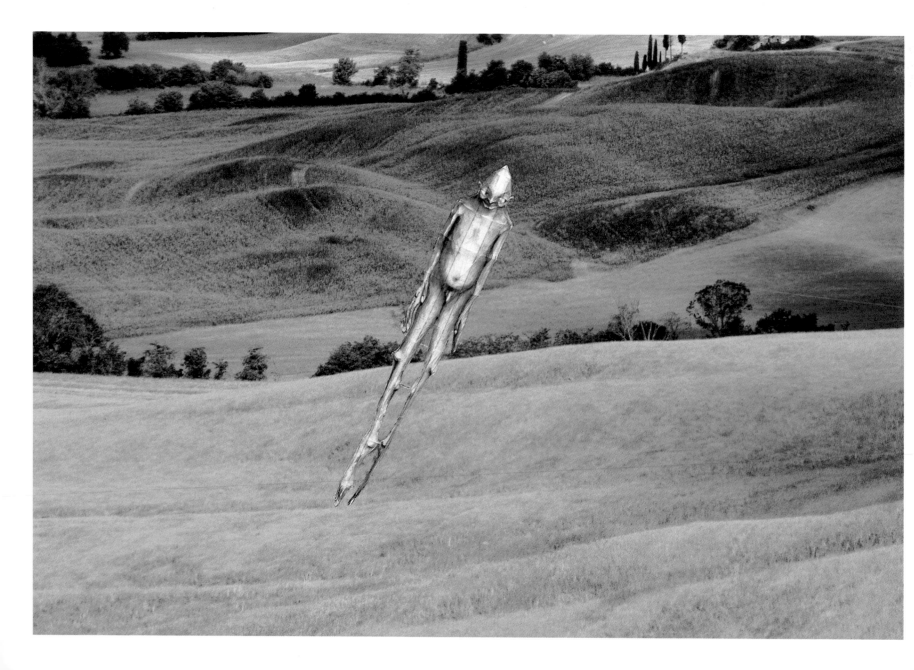

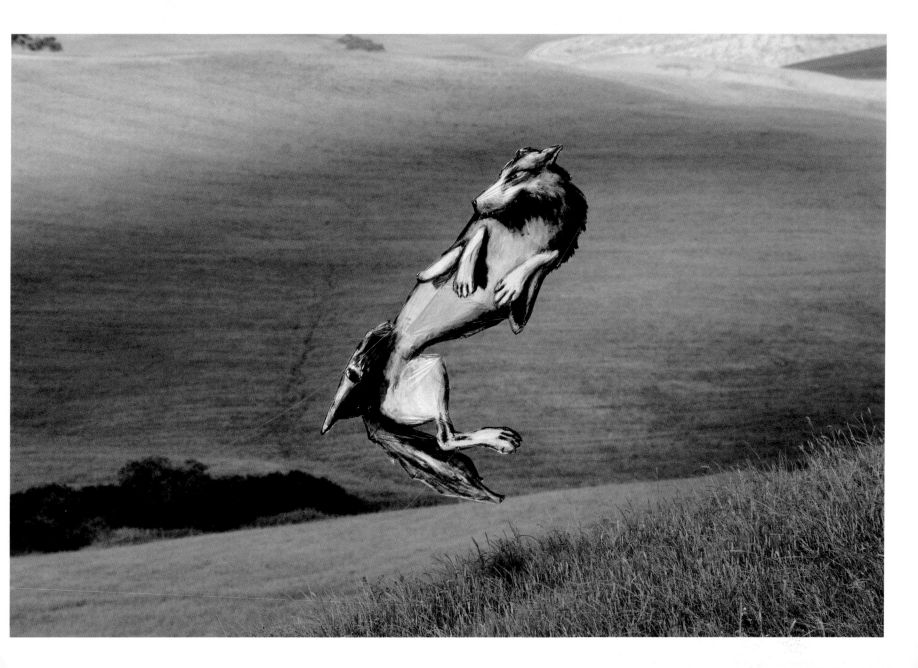

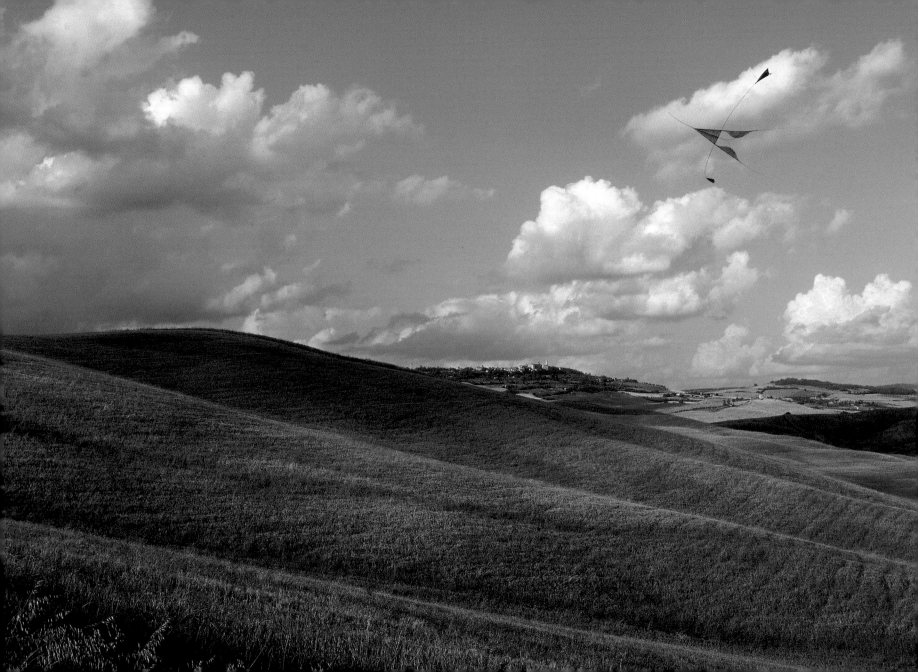

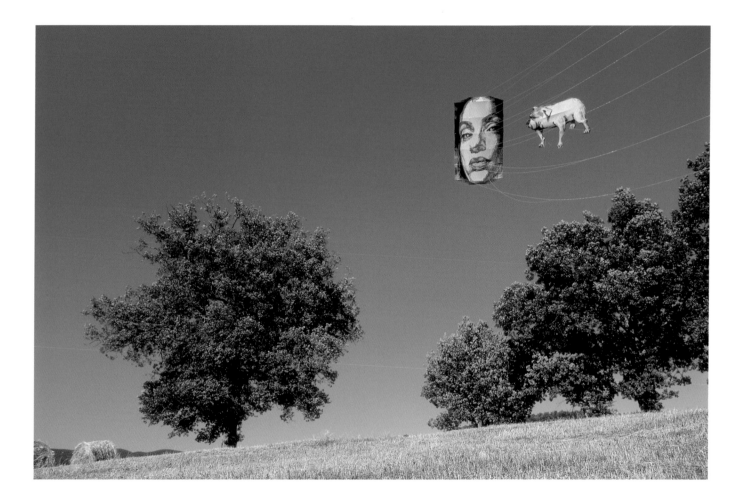

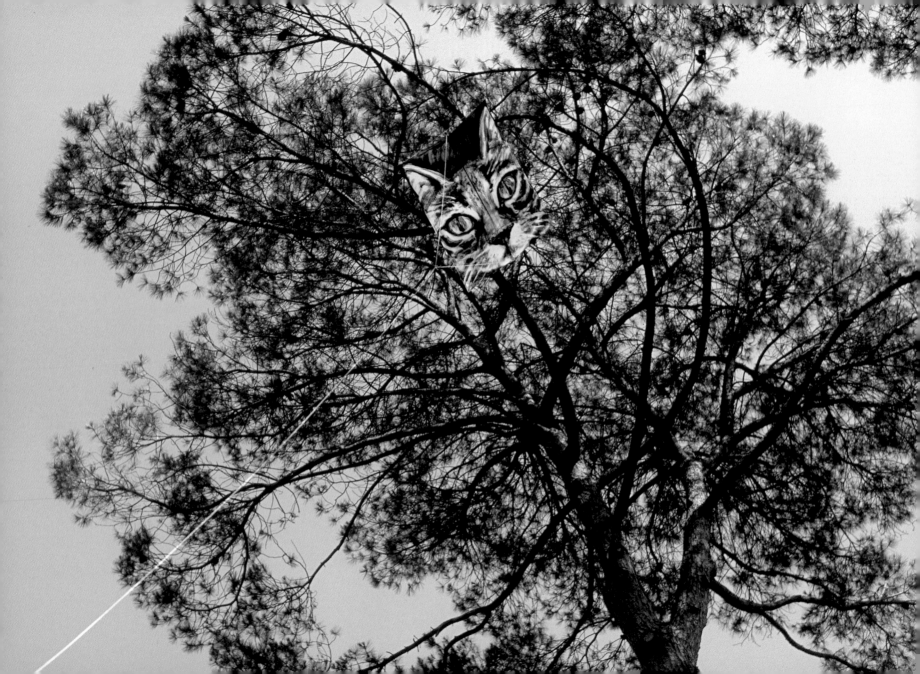

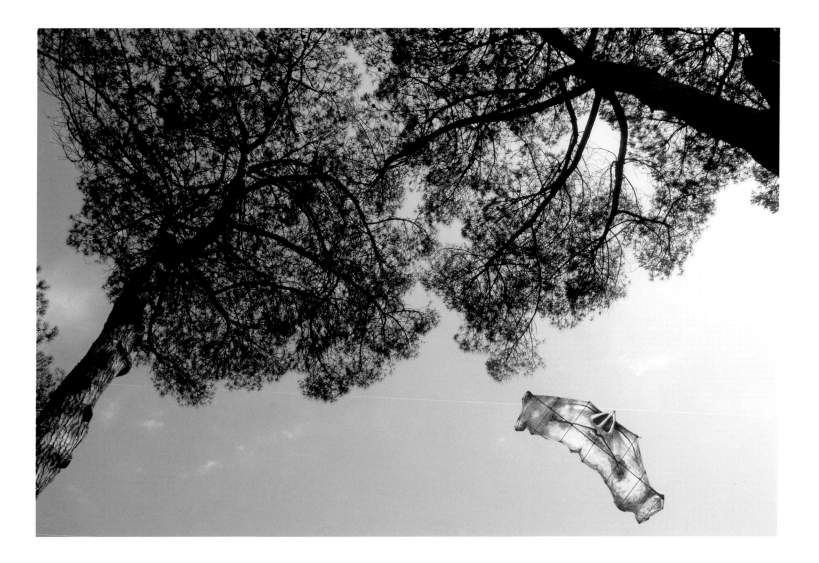

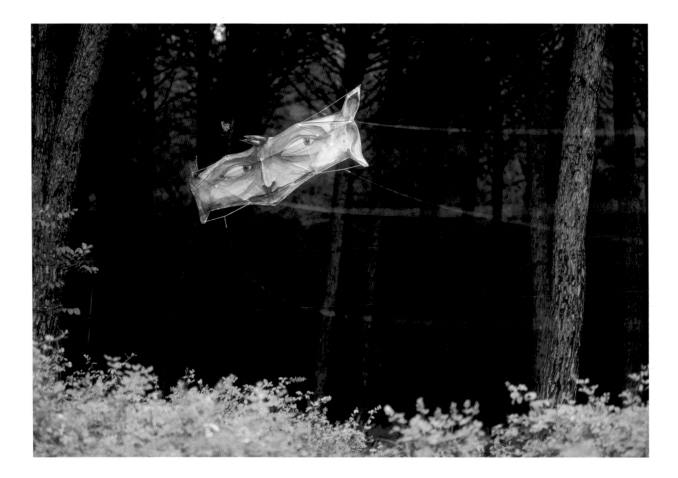

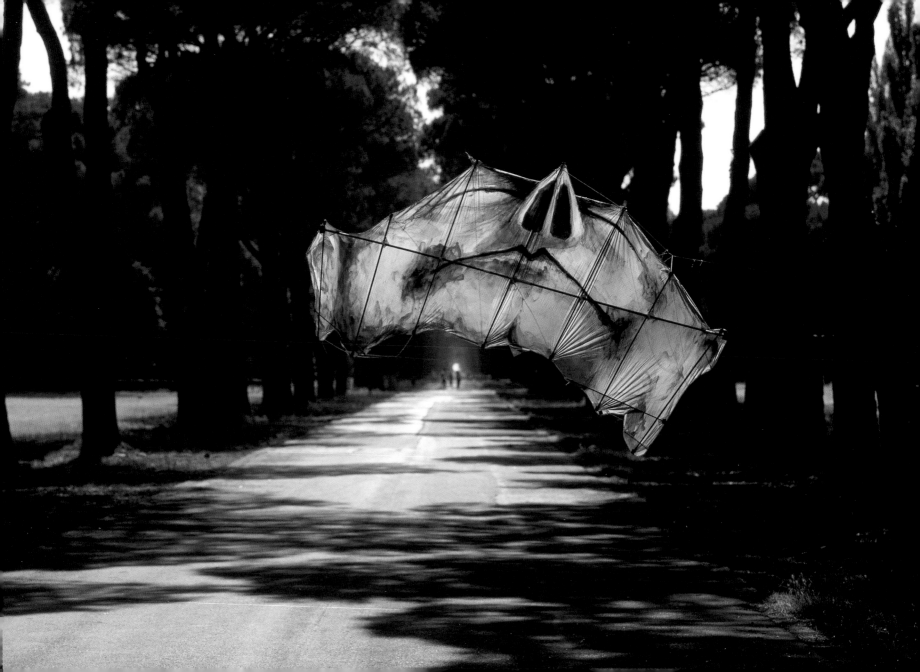

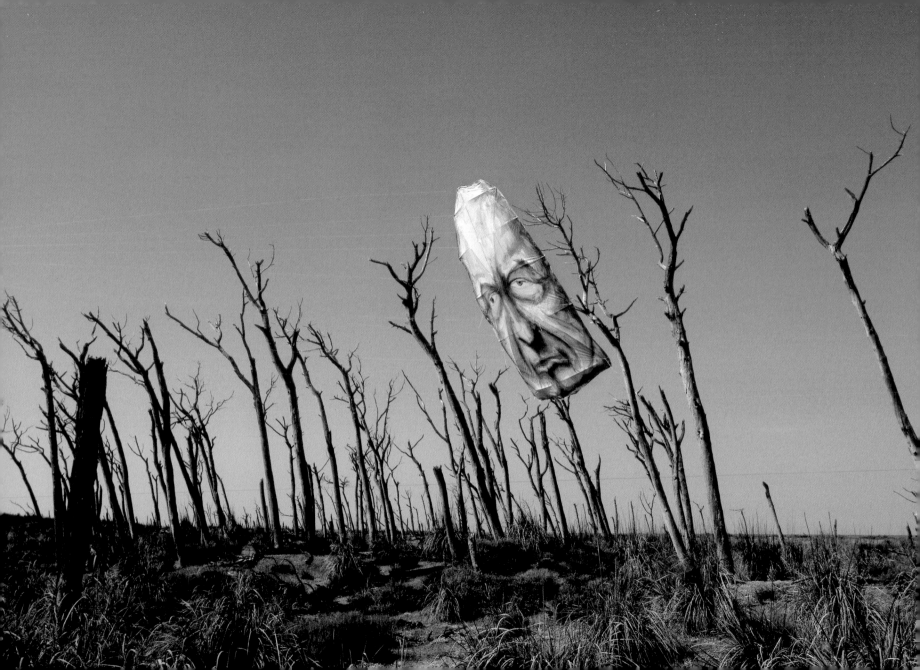

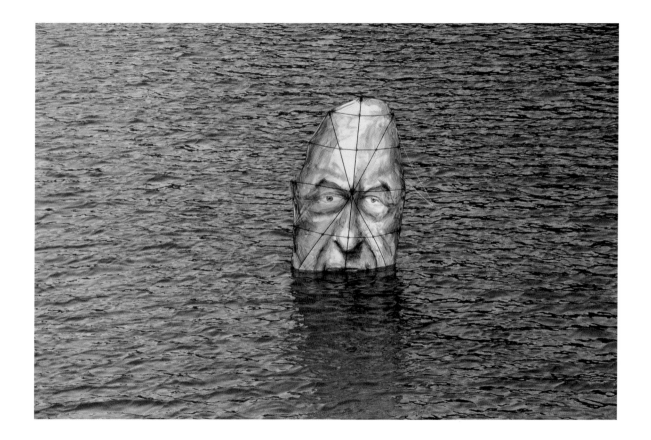

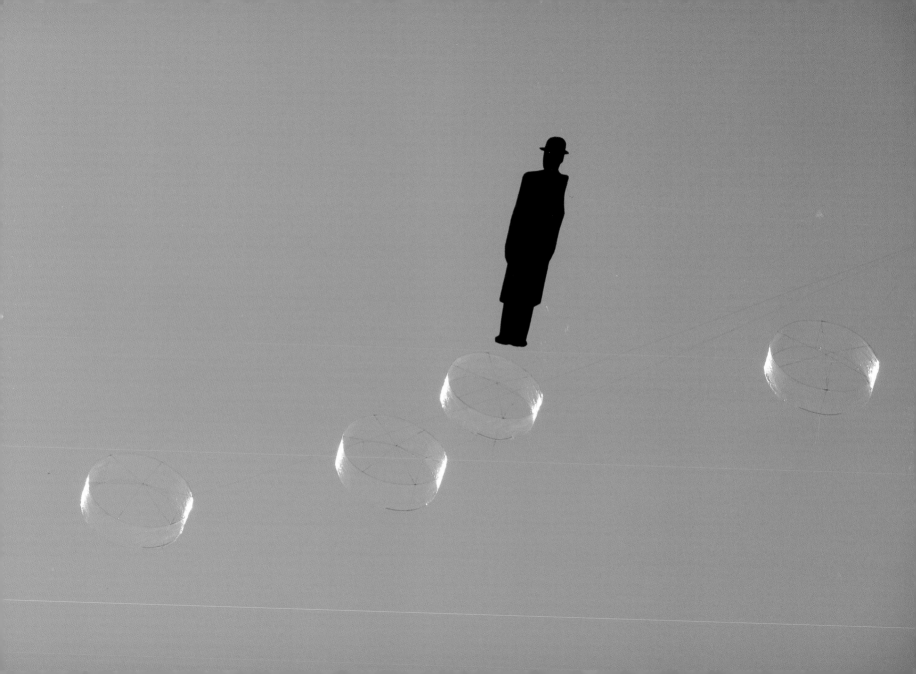

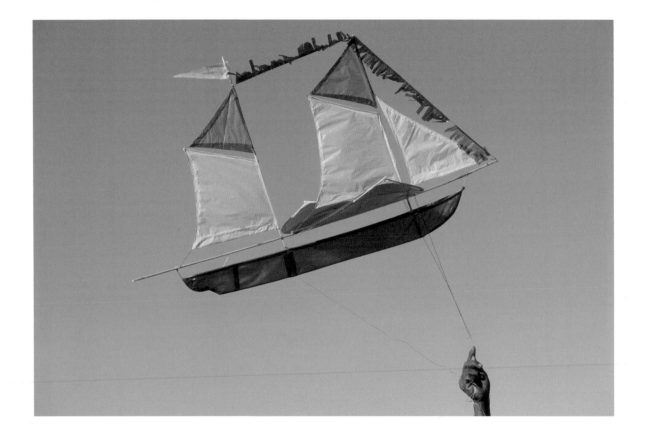

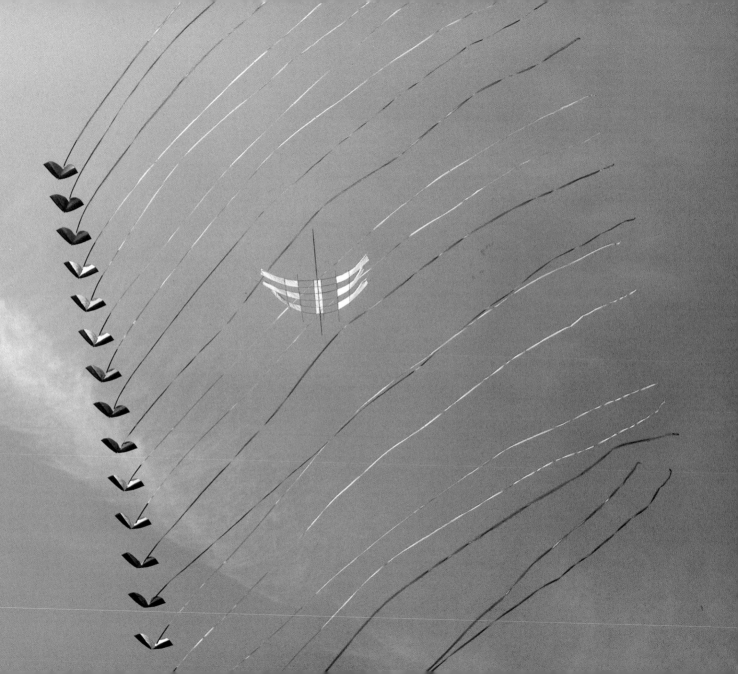

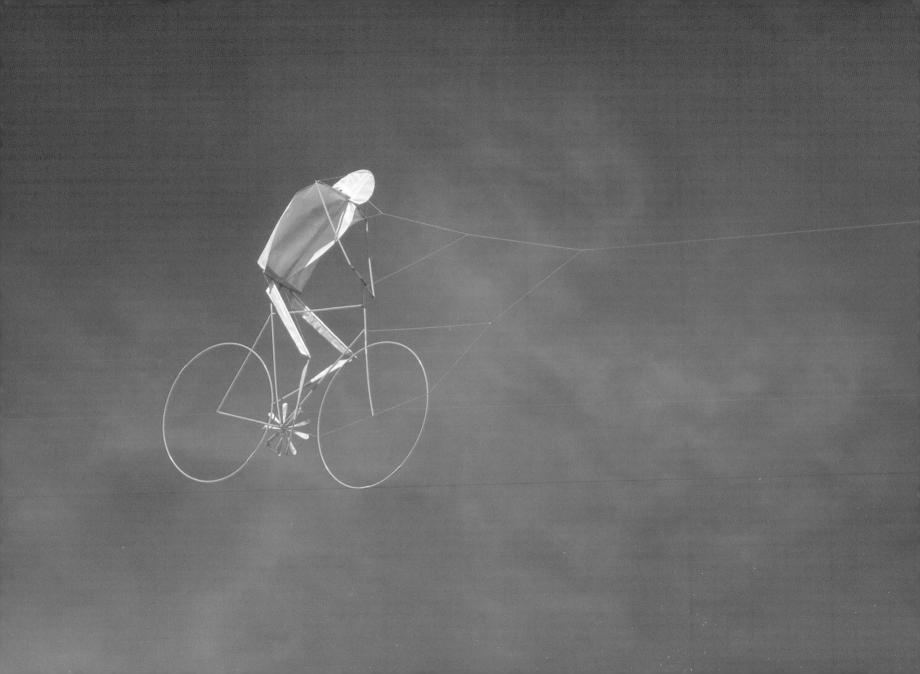

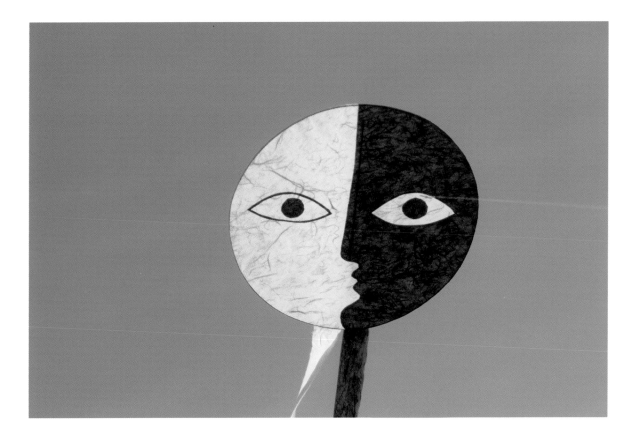

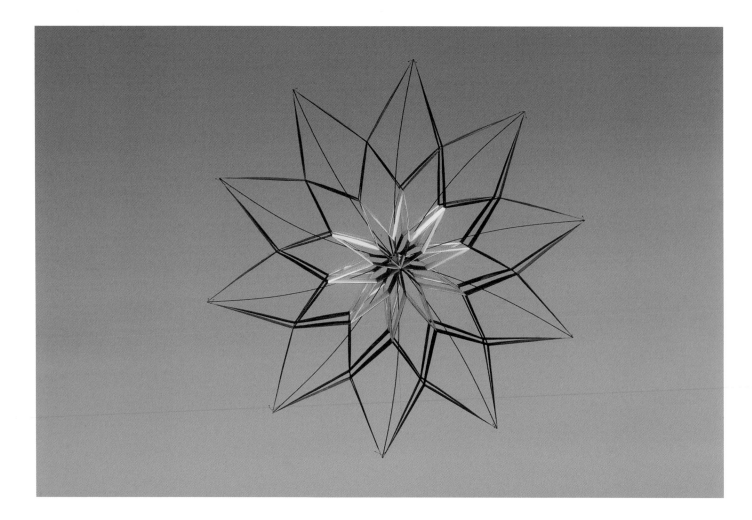

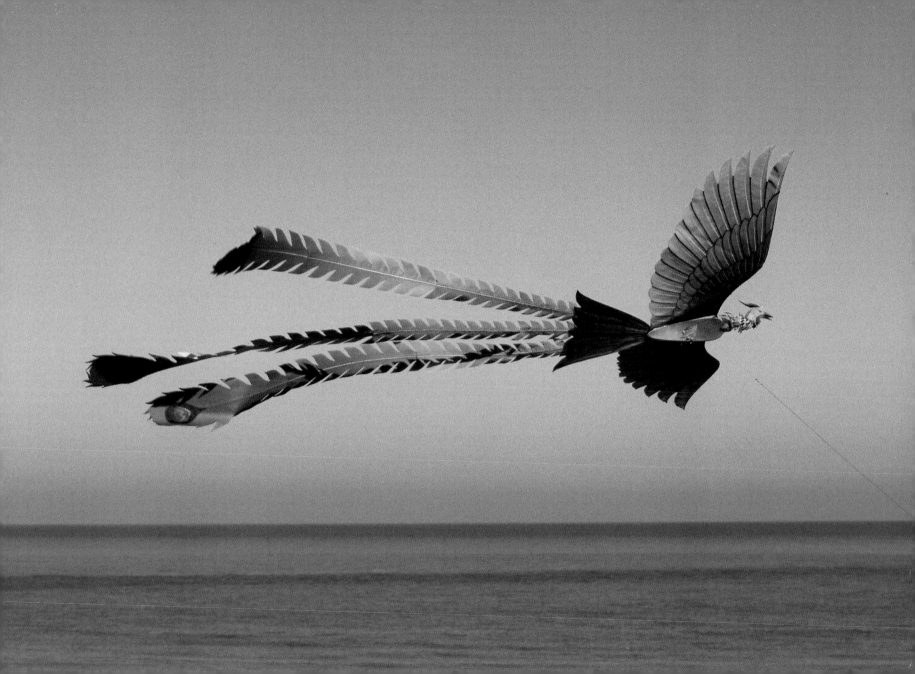

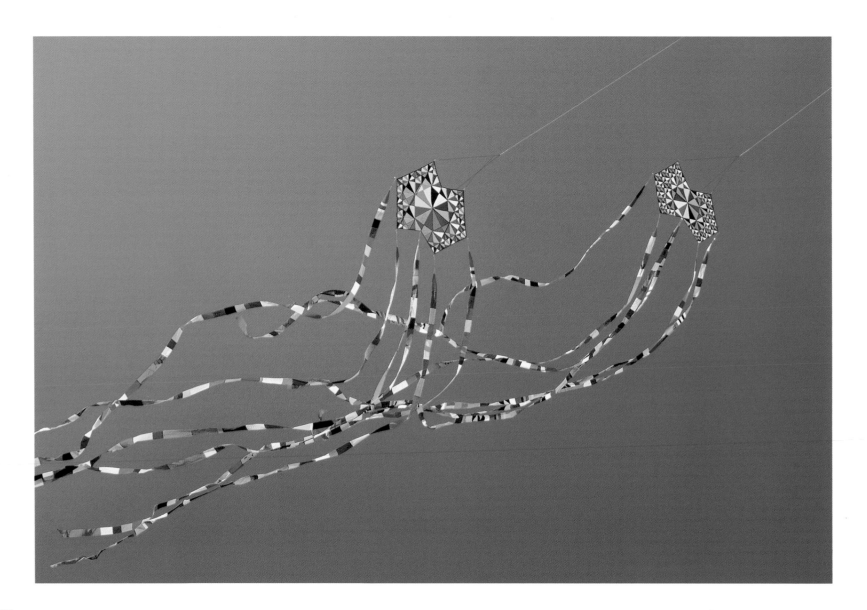

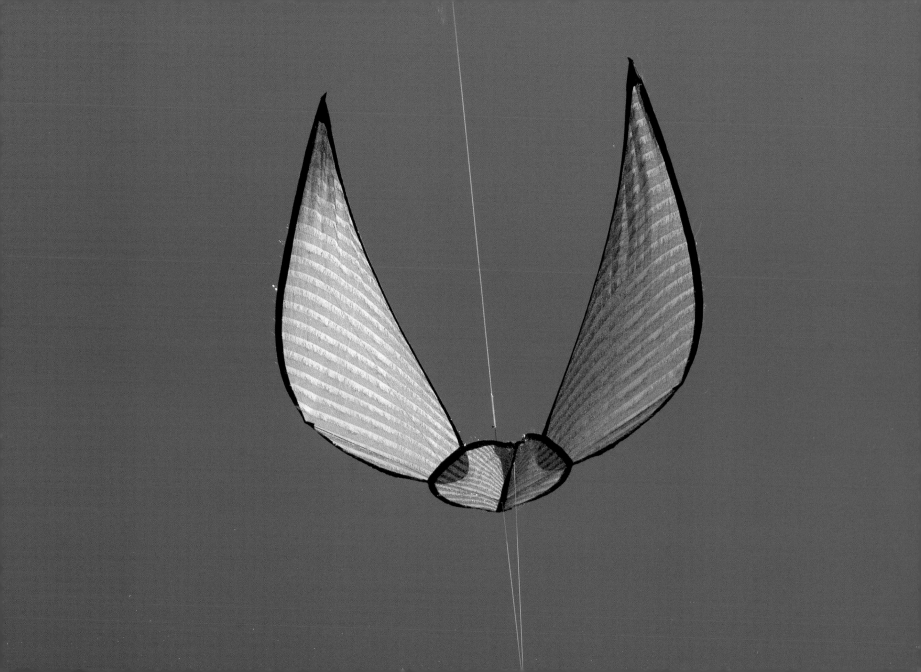

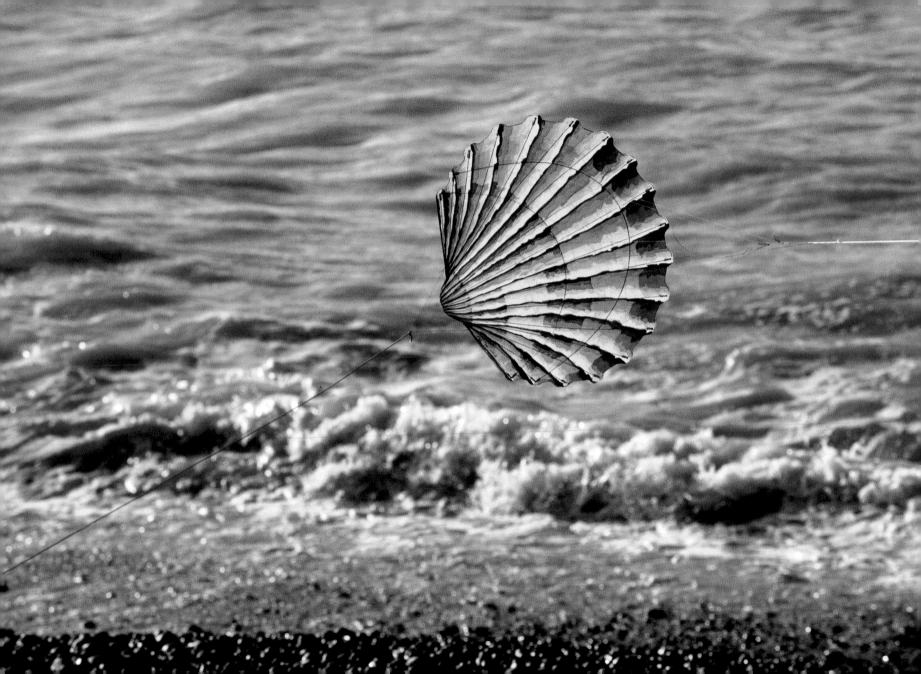

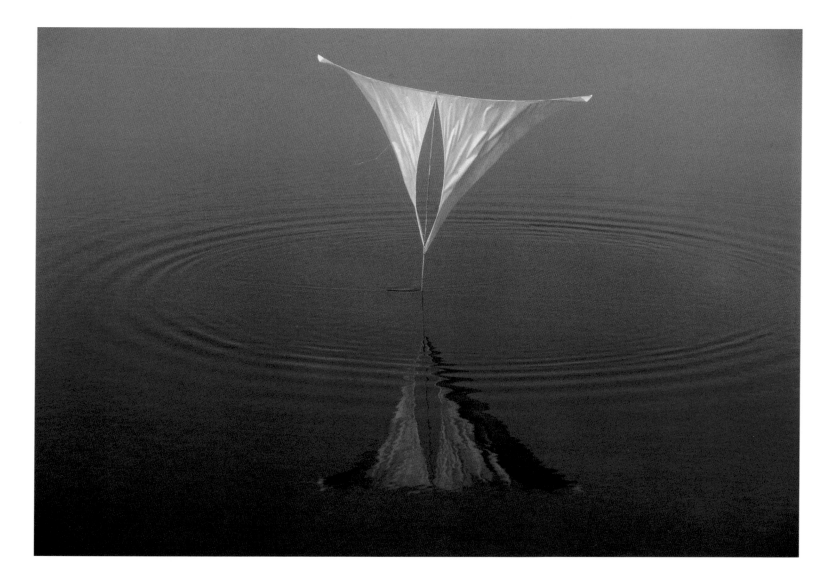

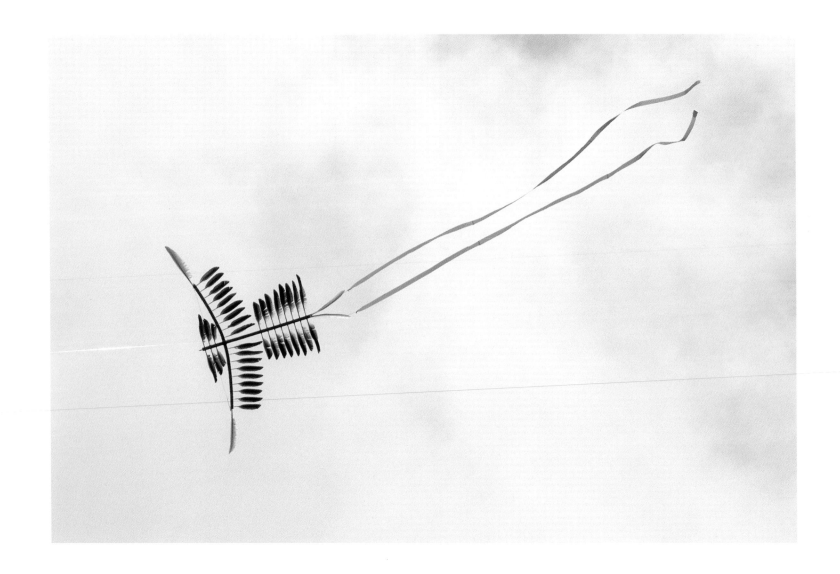

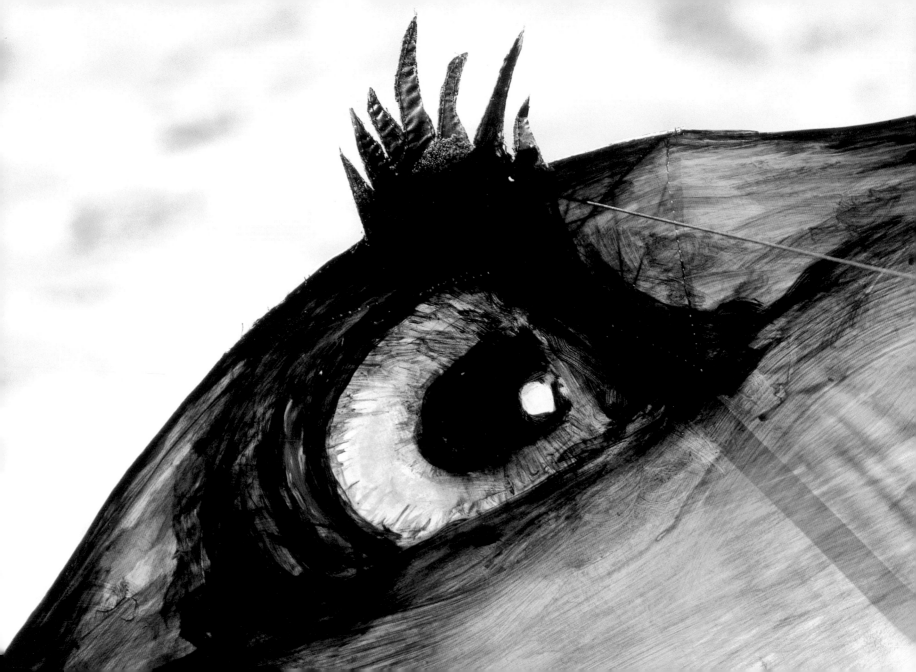

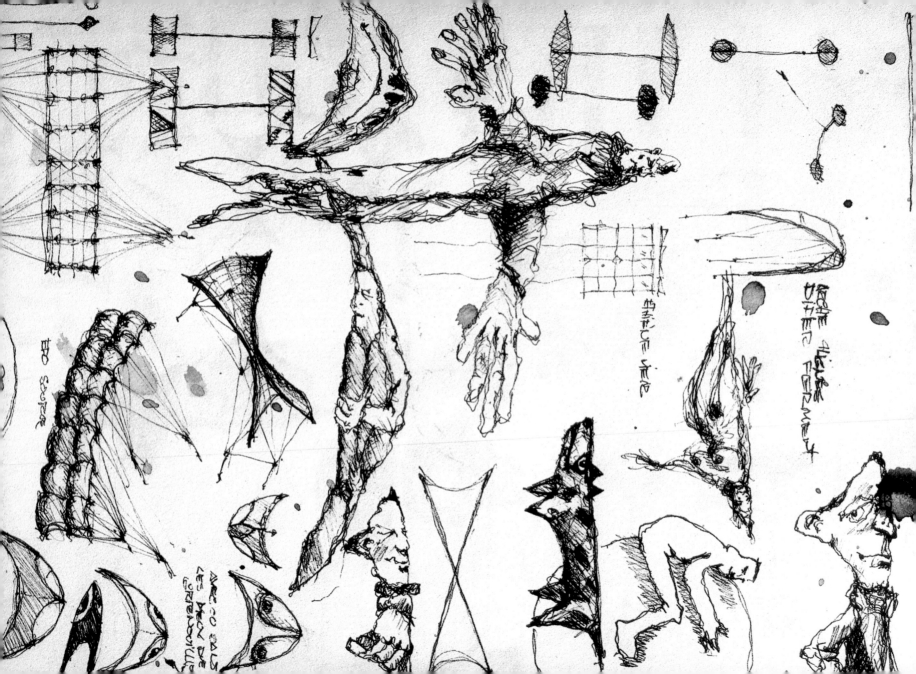

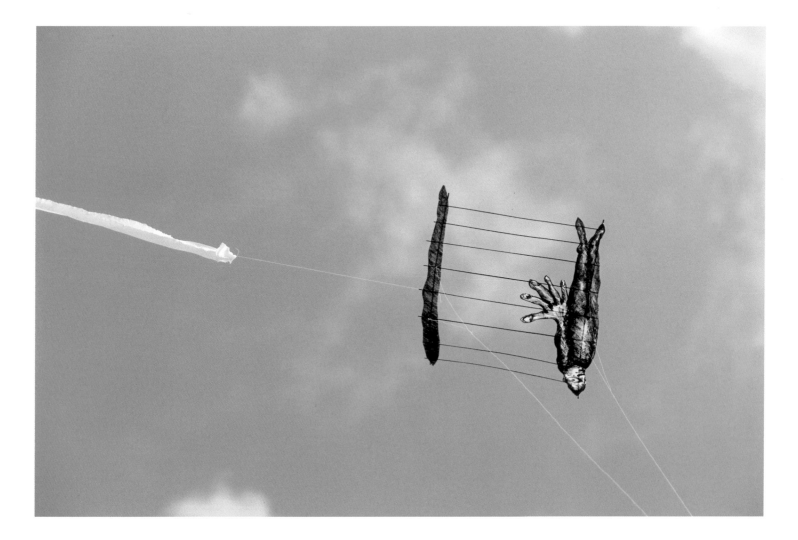

A kite, like us, needs air to live. But a kite needs more: It must have air that is in motion. Without wind, the kite is dead, an empty, soulless, discarded thing. But once it is launched on a breeze, it is an object that makes us dream of flying with our own wings.

What is a kite exactly? A child's toy or a work of art? A crafty object or an aerial wonder? Probably some of each. Its creators give it form, color, personality, and life. Attached to a cord, once into the wind and aloft it shows what it can do (for the connoisseur, there is a great difference between keeping a kite in the air and flying it with expertise). Today kite flying is immensely popular and enriched by the innumerable variants invented by enthusiasts throughout the world. Yet the kite itself remains a poetic object, exquisitely old fashioned and mysterious. Whether it takes the form of a mask, a bird, a seashell, a boat, or a bicyclist hardly matters.

The kite's quest for the wind is a kind of dream adventure. "The value of an image," wrote Gaston Bachelard, "is measured by the breadth of its imaginary aura. The true poetic image does not describe but it evokes, draws forth memories, engenders dreams, and opens a world of infinity." The kite is a perfect illustration for this: Watching it in flight, we see the full breadth of its "imaginary aura" and within that aura the inkling of a dream existence in the wind. That is the sphere of pure imagination.

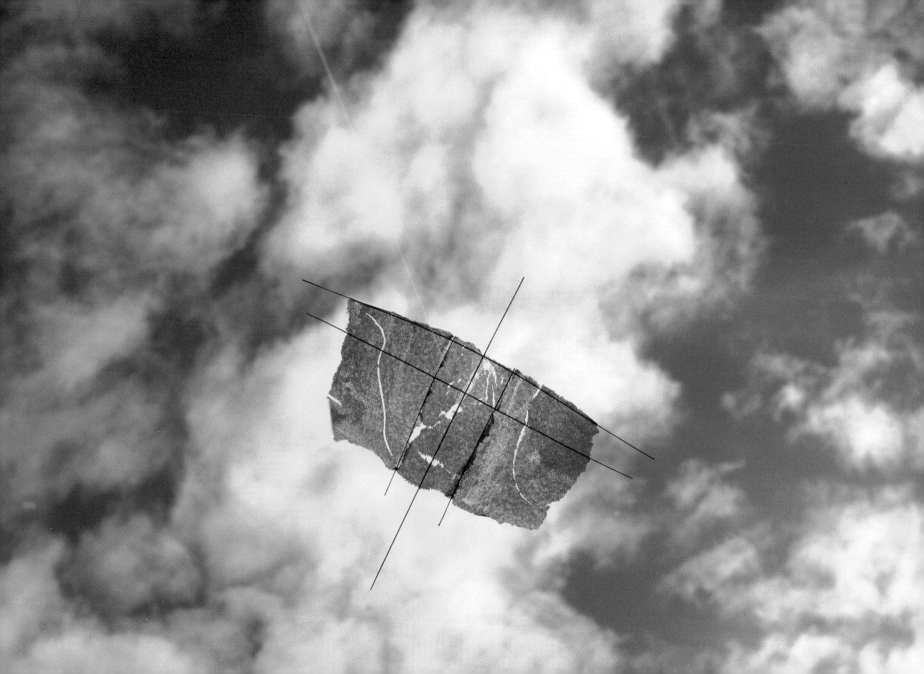

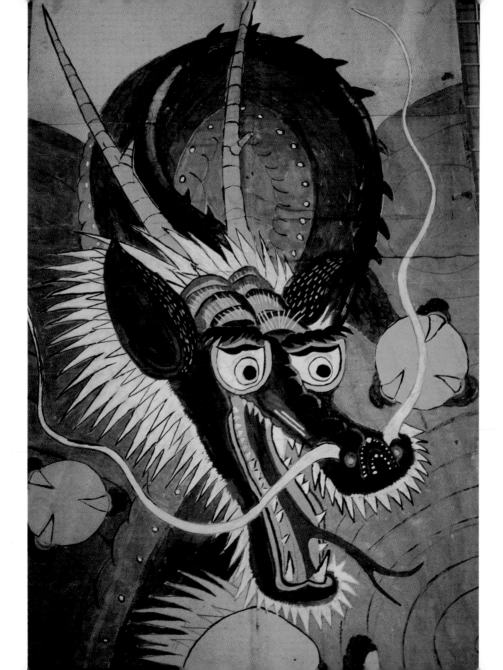

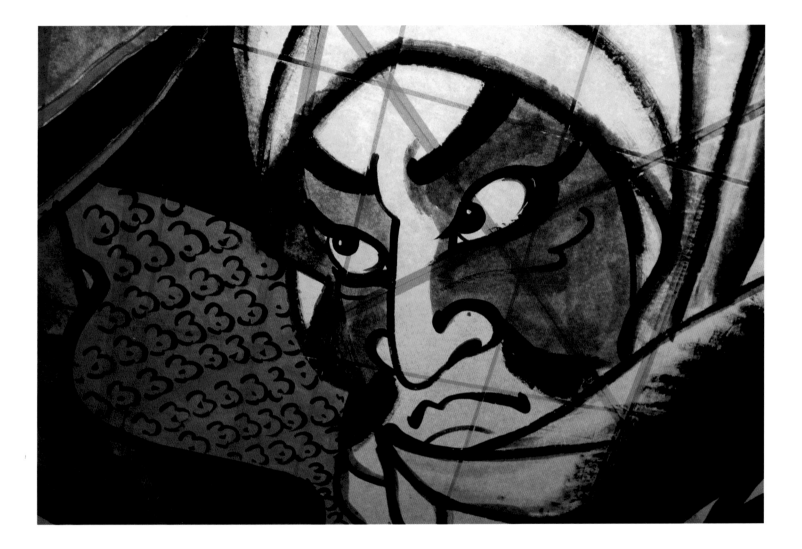

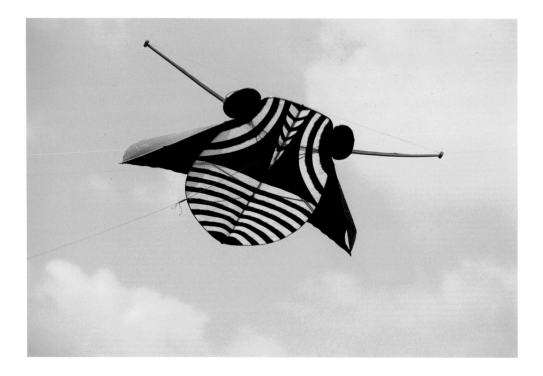

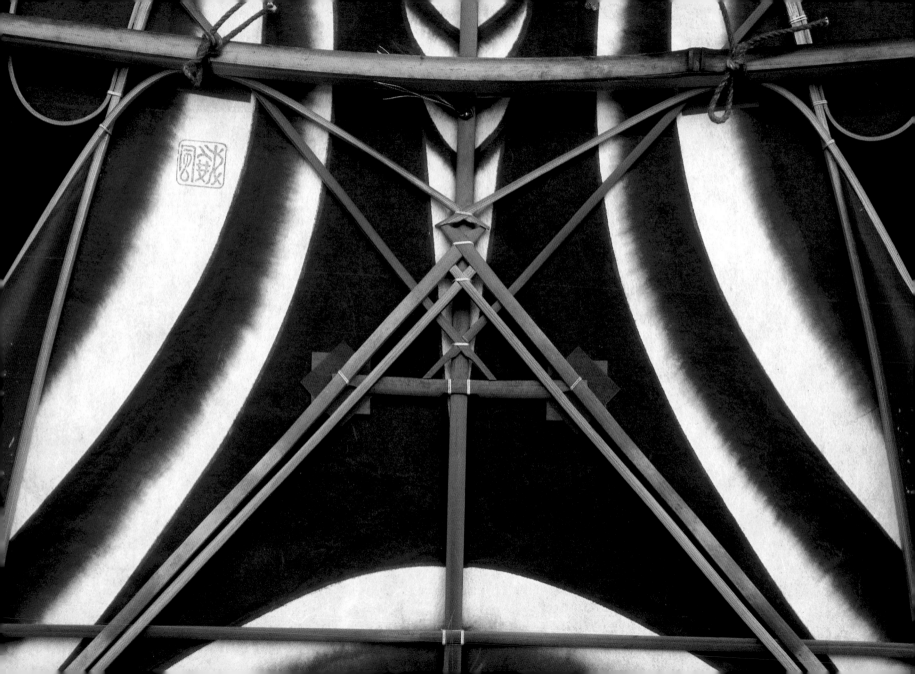

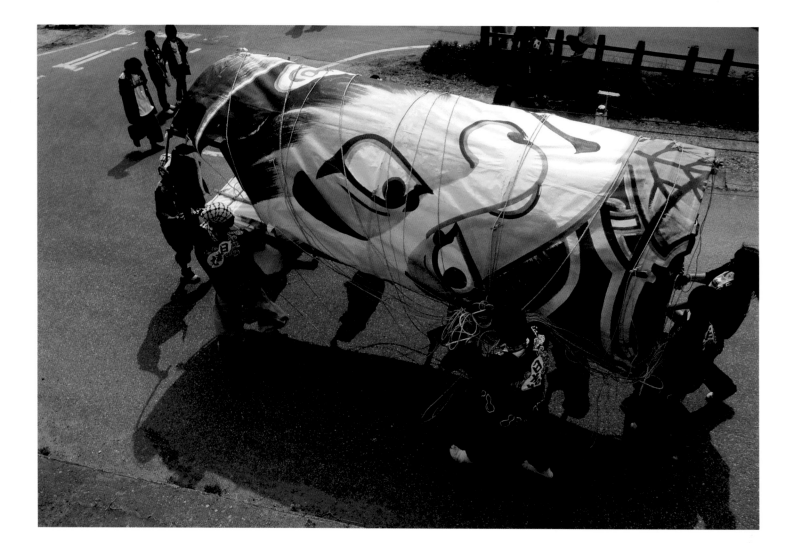

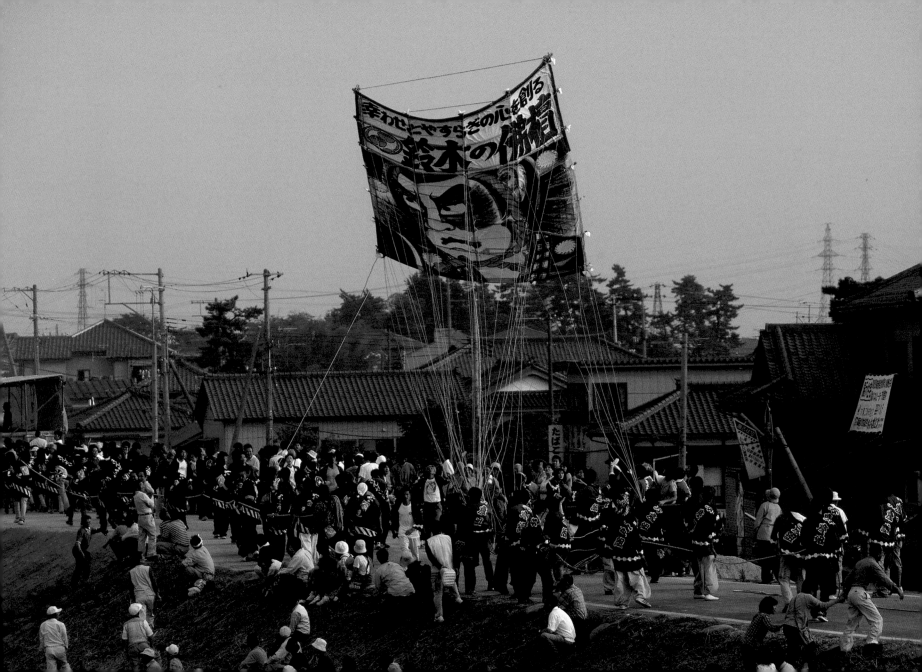

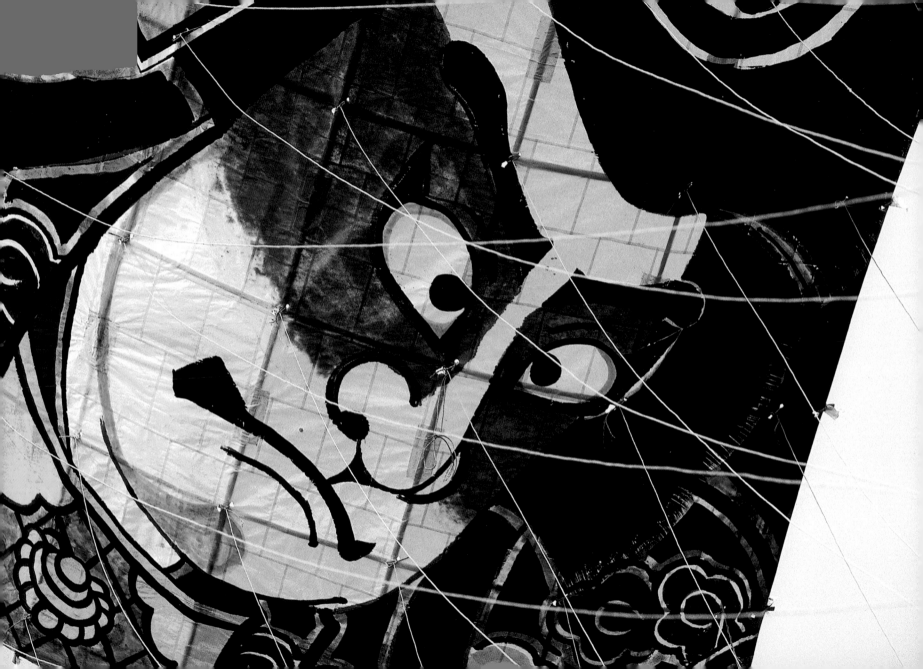

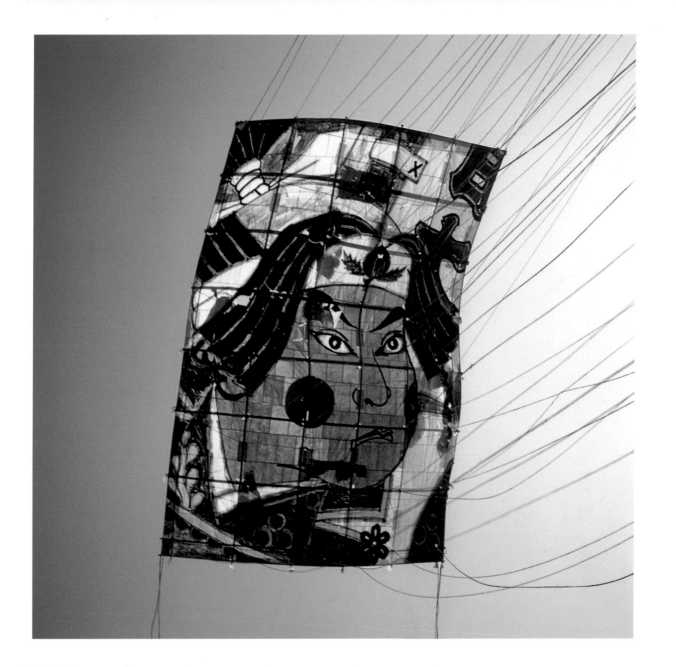

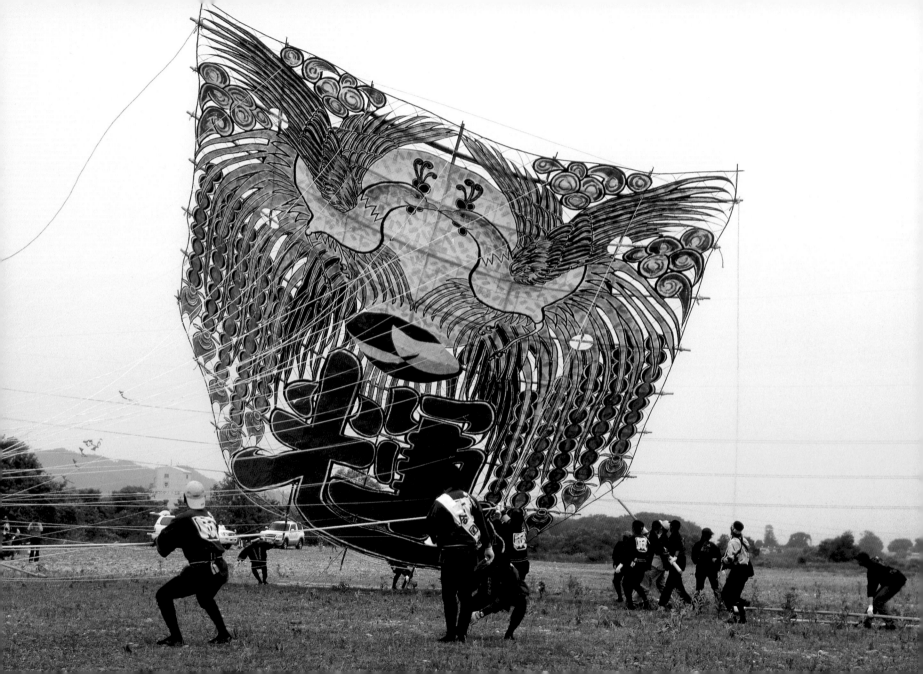

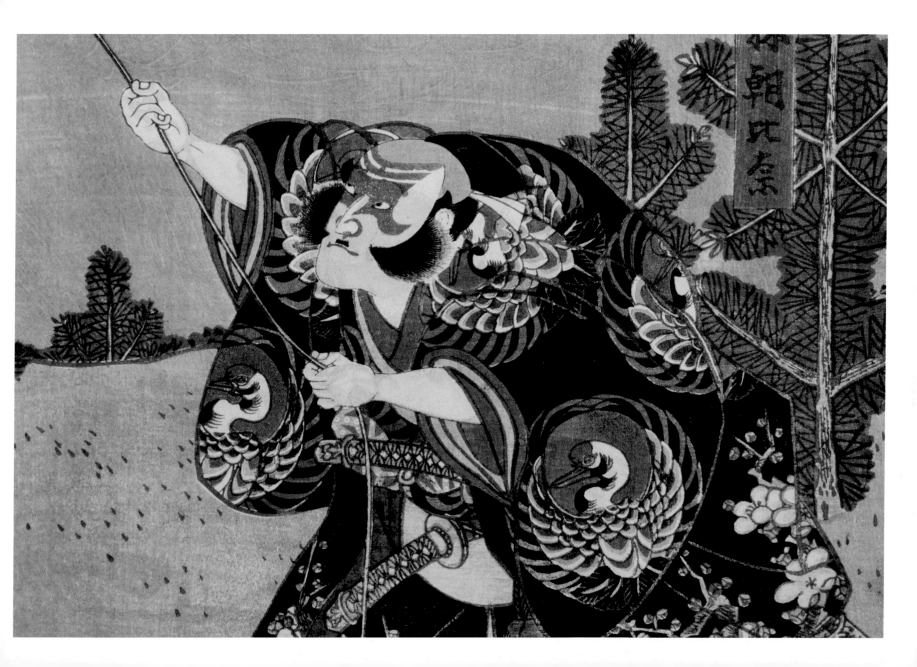

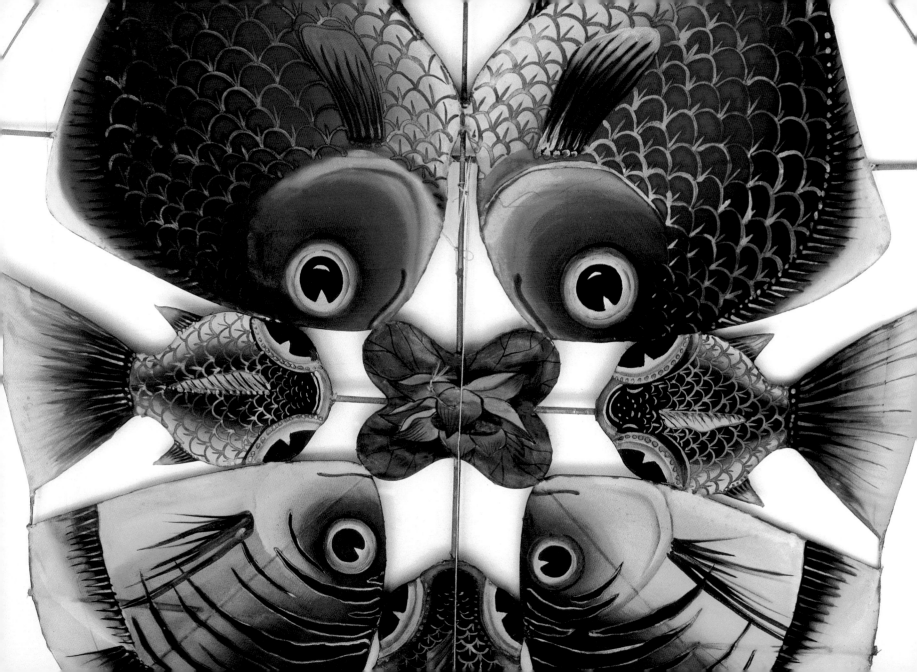

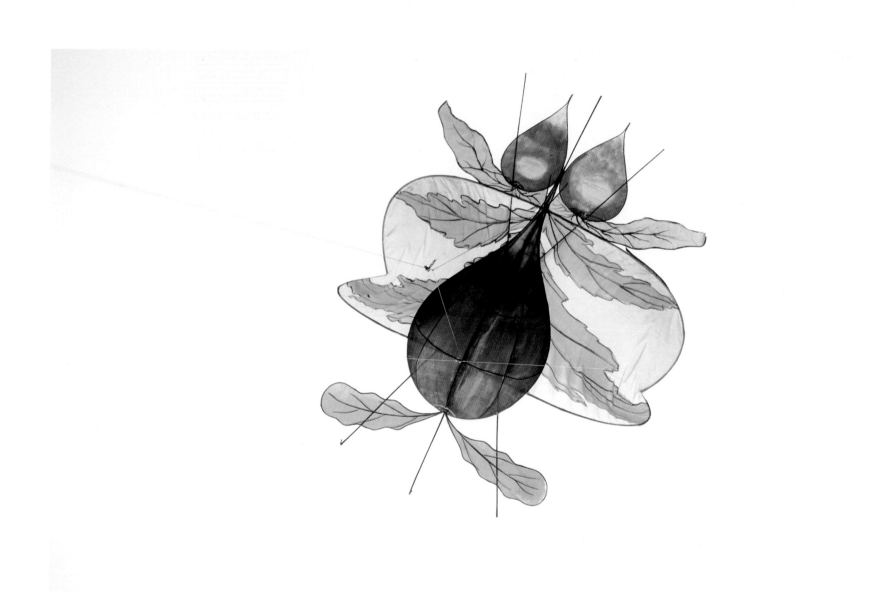

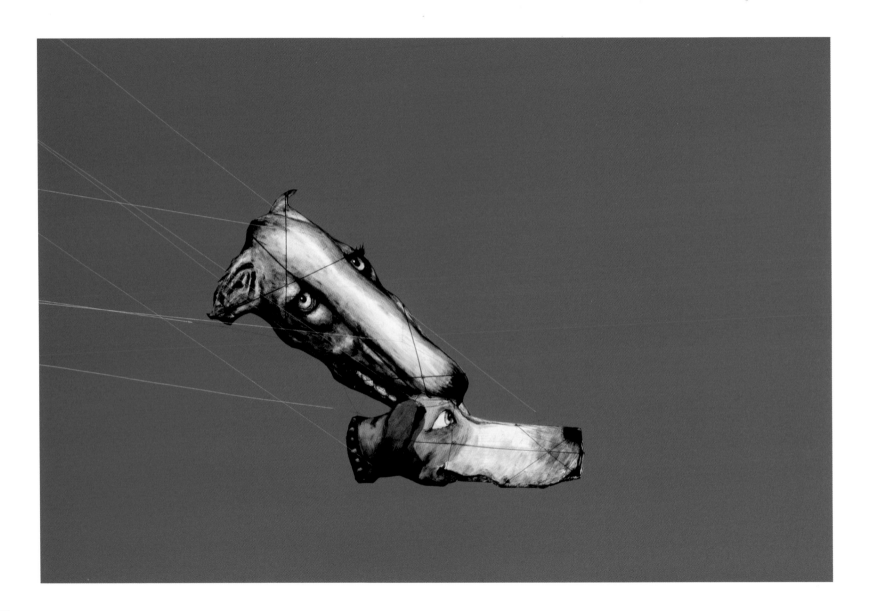

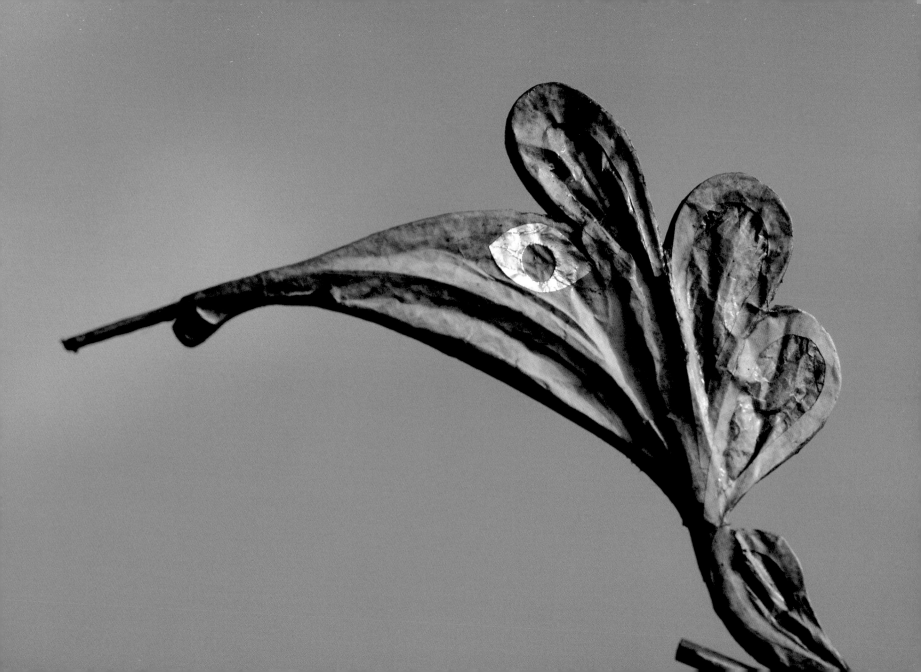

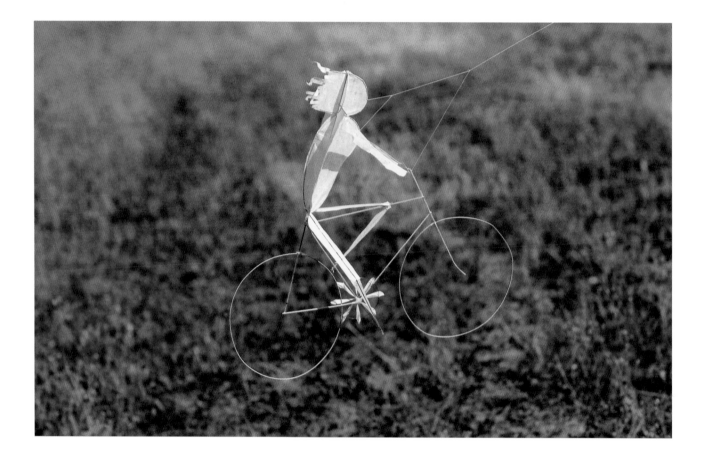

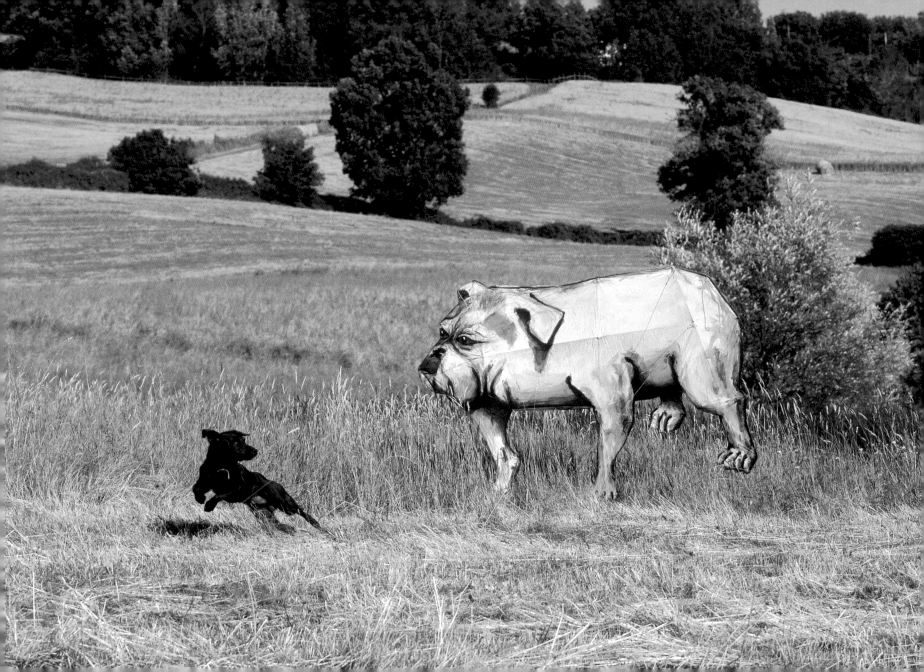

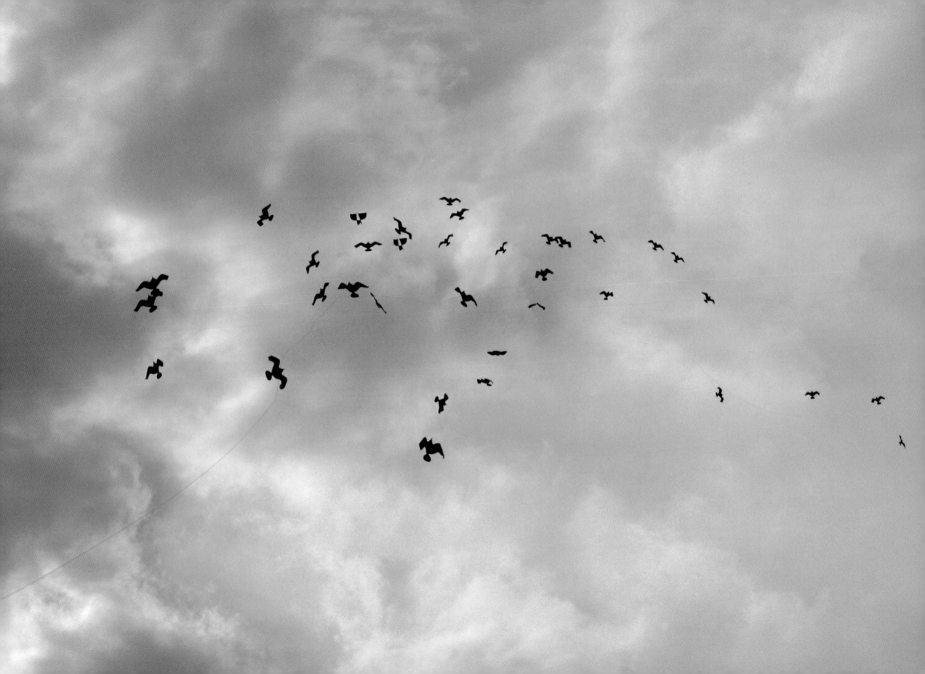

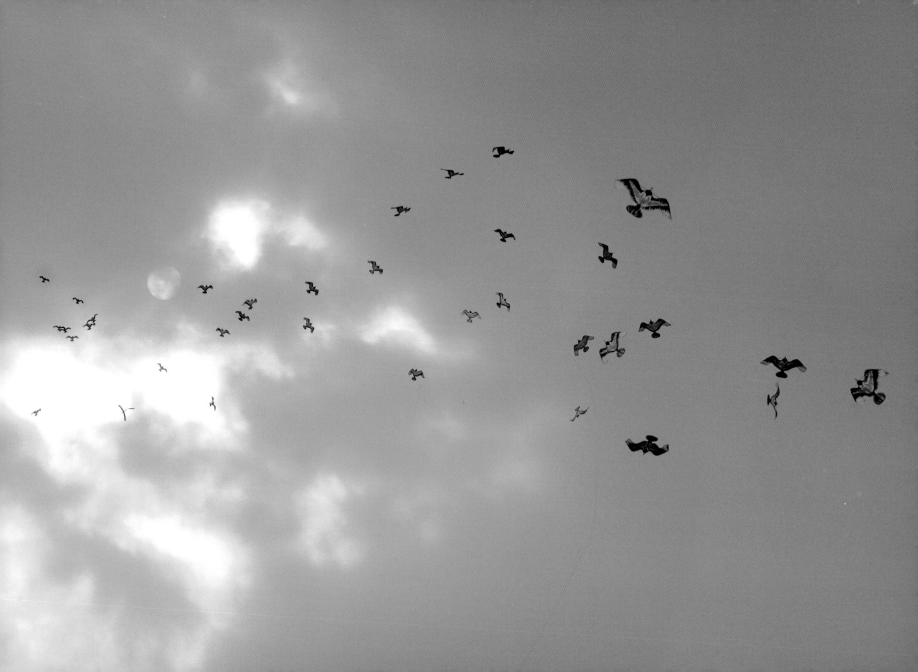

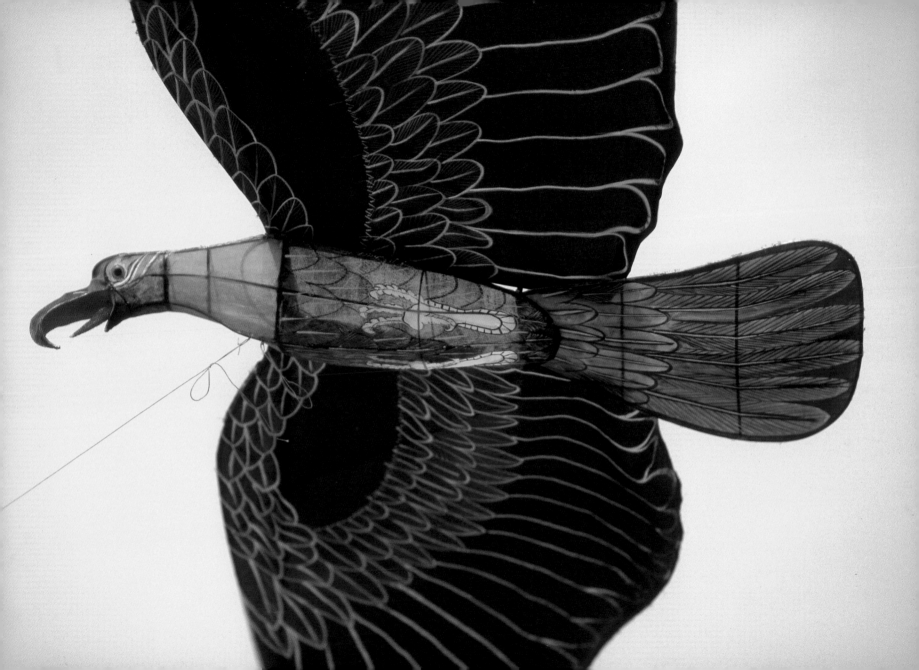

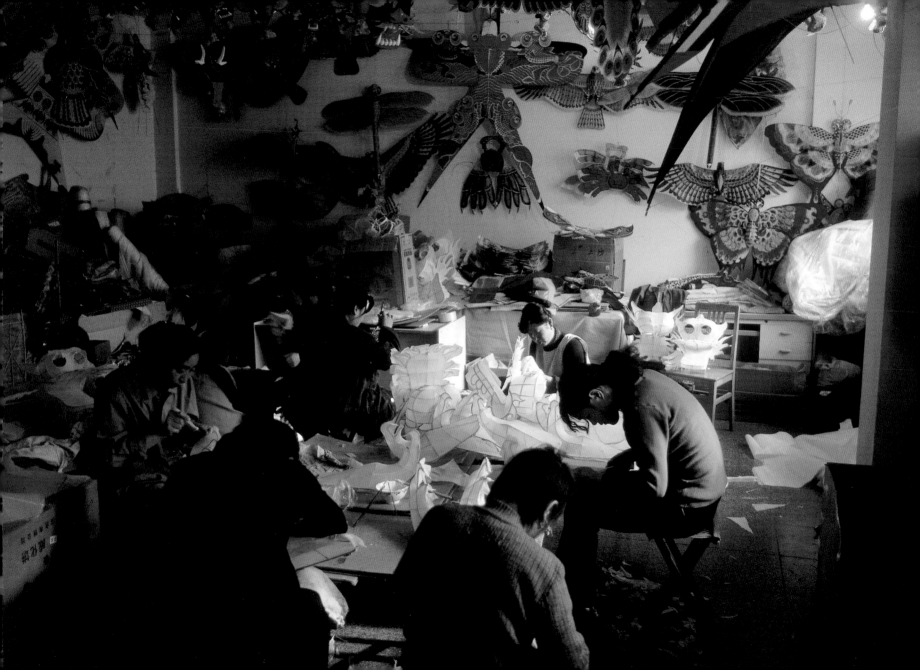

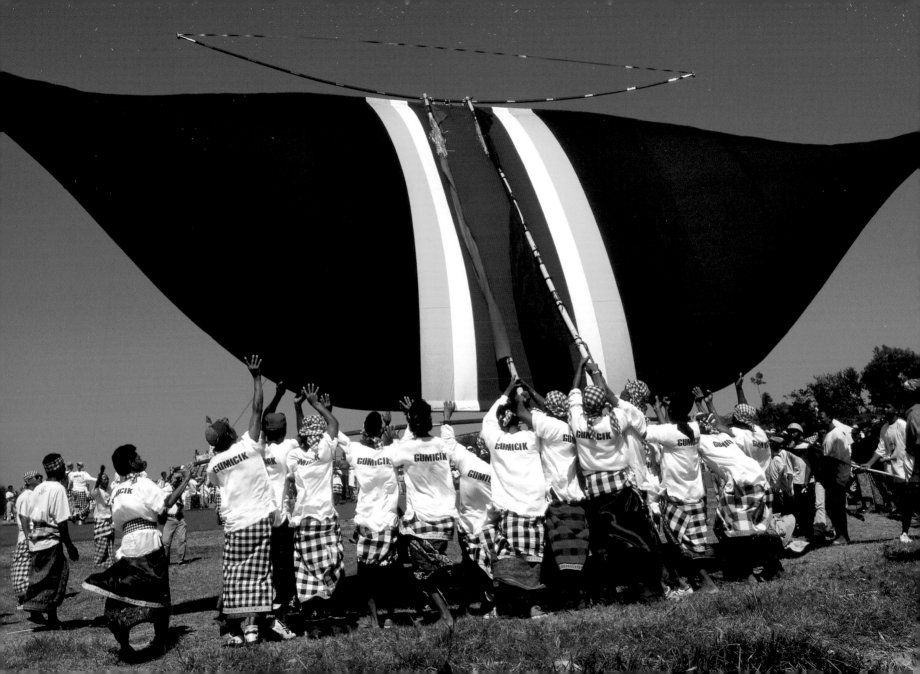

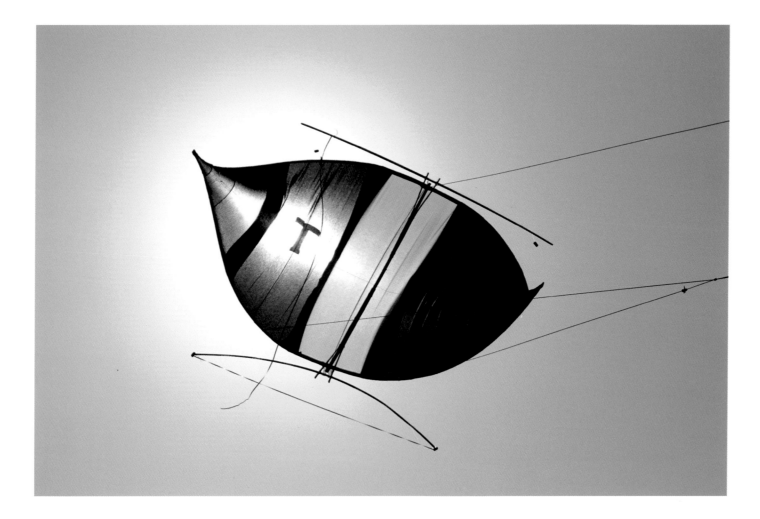

163

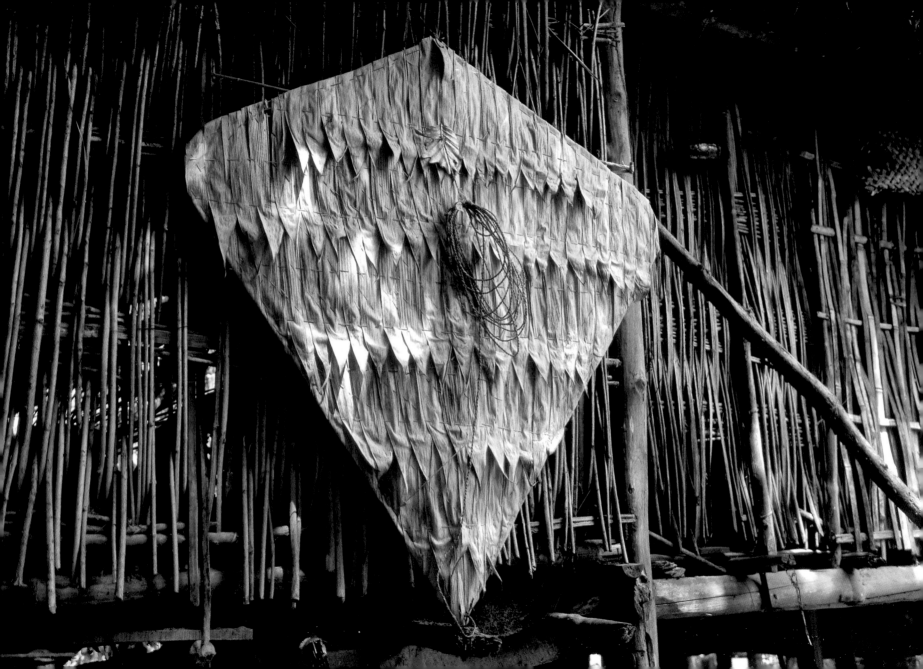

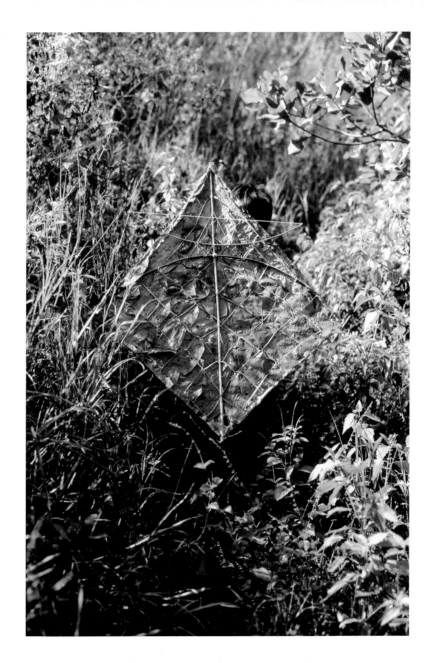

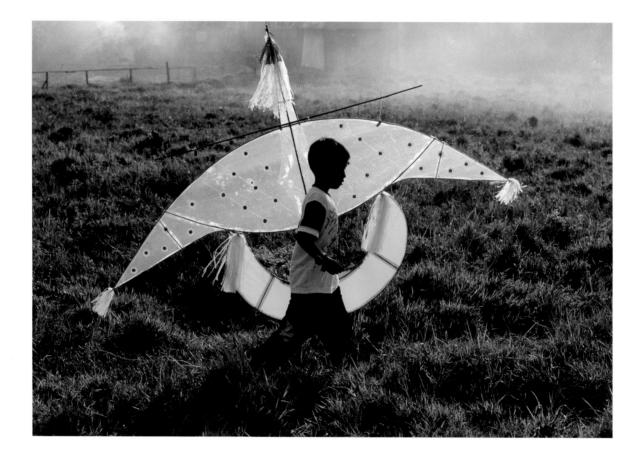

166

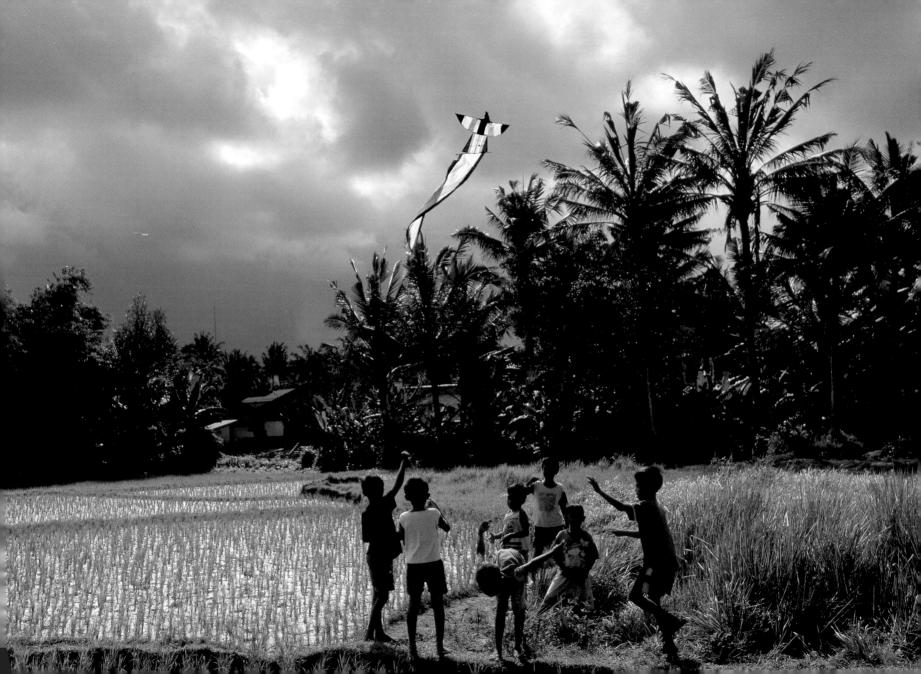

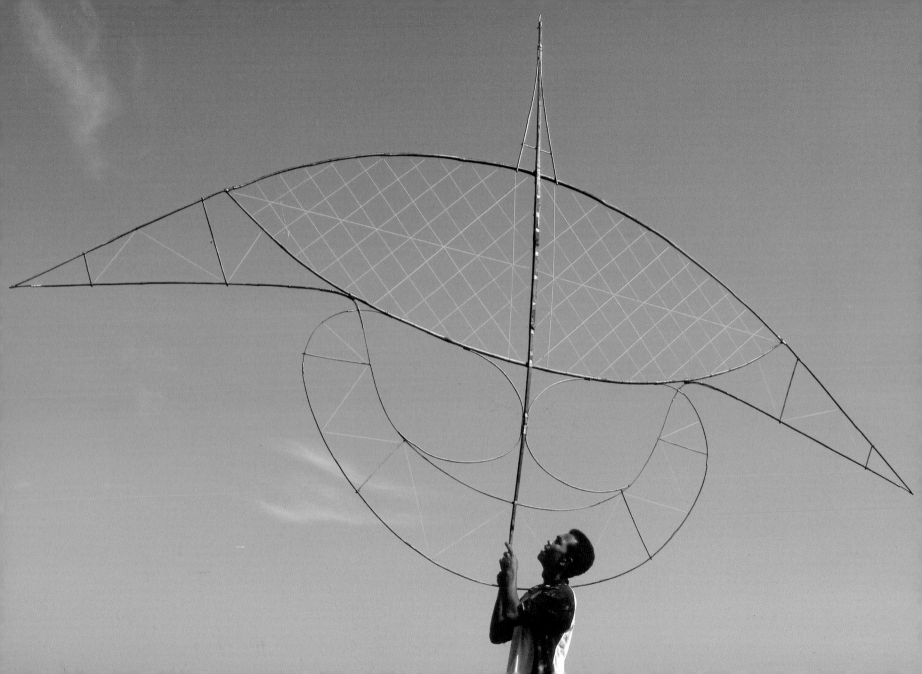

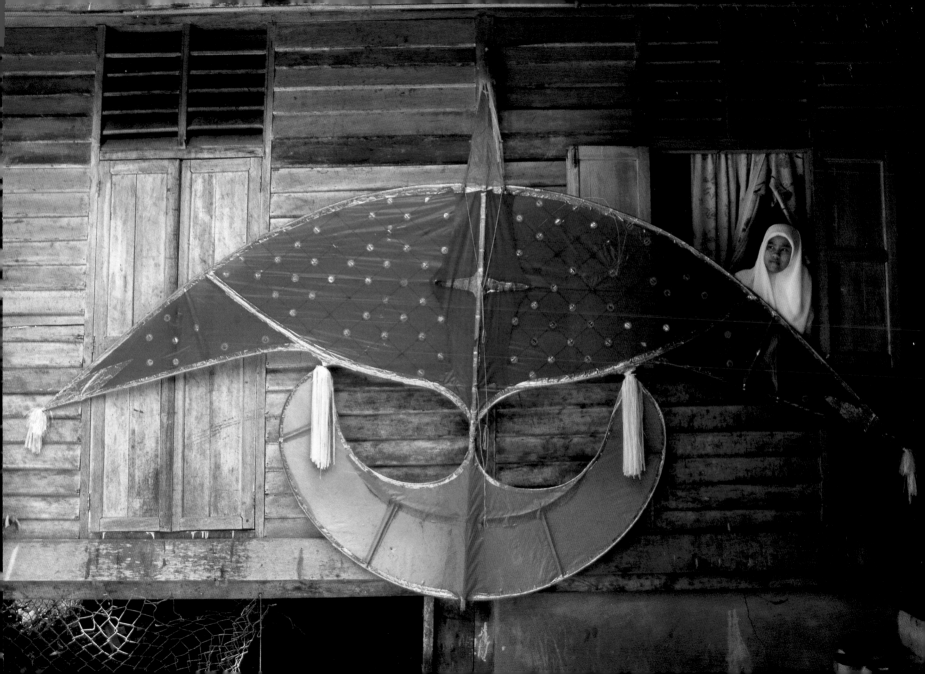

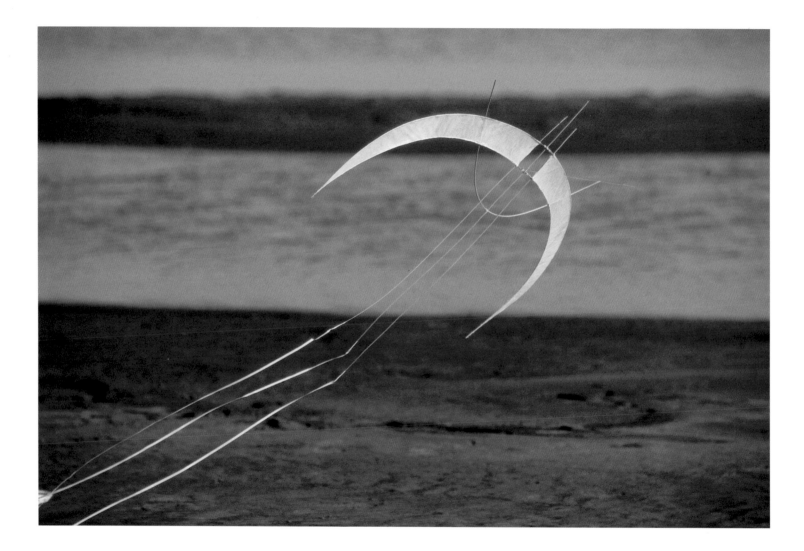

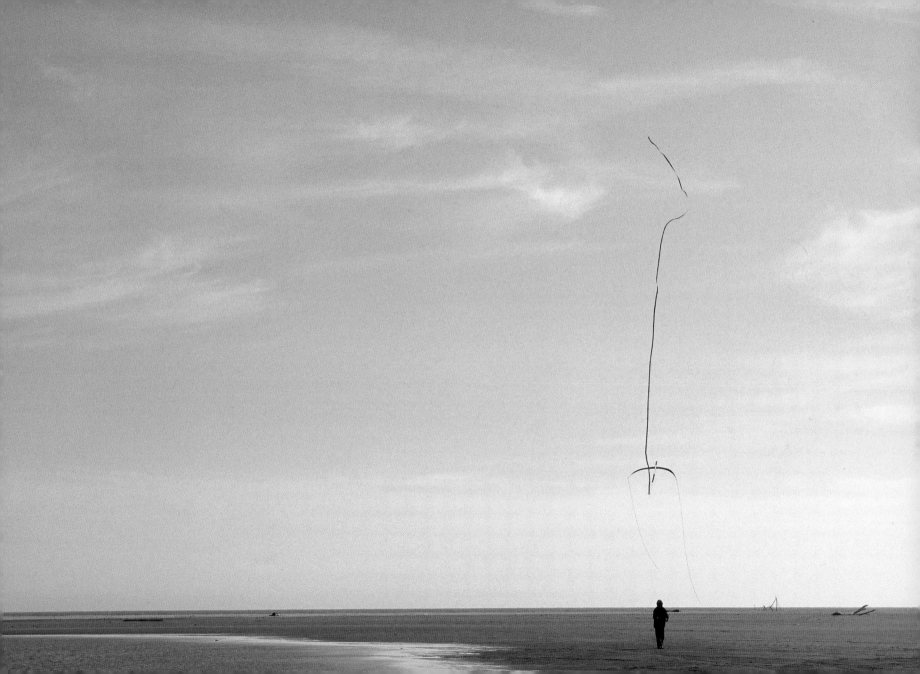

CAPTIONS

Endpapers: Kite paper cutout MALAYSIAN

Frontispiece: Painted kite CHINESE

Title page: White heron INDONESIAN

Pages 7-8: Kite paper cutout MALAYSIAN

Pages 9-13: CHINESE

Page 14: Le Cerf qui vole (The Flying Deer) CHINESE

Pages 15-19: CHINESE

Page 20: O-dako (Giant Kite) JAPANESE

Page 21: JAPANESE

Pages 22-23: Drawings. World Kite Museum, Yokaichi, Japan CHINESE

Pages 24-25: Prints JAPANESE

Pages 26-27: Drawings. World Kite Museum, Yokaichi, Japan CHINESE

Page 28: Wall painting at Mandawa, Shekawati INDIAN

Page 29: Drawings. World Kite Museum, Yokaichi JAPANESE

Pages 30-33: CHINESE

Page 34: The Cervia International Kite Festival in Italy

Page 35: INDONESIAN

Pages 36-37: CHINESE

Page 38: Kite by Johan Hallin SWEDISH

Pages 39-43: CHINESE

Page 44: Bali INDONESIAN

Pages 45-47: CHINESE

Page 48: VIETNAMESE

Pages 49-53: CHINESE

Pages 54-65: The Day of the Dead. Santiago Sacatepéquez Cemetery in Guatemala

Page 67: MALAYSIAN

Pages 68-69: Kites by the artist Curt Asker SWEDISH

Page 70: Kites by Philippe Cottenceau FRENCH

Page 71: Kite by Kirsten "Kisa" Sauer GERMAN

Pages 72-73: Kites by Philippe Cottenceau FRENCH

Page 74: Kite by Kisa GERMAN

Page 75: Kites by Philippe Cottenceau FRENCH

Page 76: Kite by Robert Trépanier CANADIAN

Page 77: Kite by Philippe Cottenceau FRENCH

Page 78: Kite by Kisa GERMAN

Pages 80-81: Kites by Curt Asker SWEDISH

Page 82: Kite by Rambal Tien FRENCH

Page 83: Kite by Kisa GERMAN

Page 84: Kite by Jacques Durieu BELGIAN

Page 85: Kite by Philippe Cottenceau FRENCH

Page 87: Kite by Curt Asker SWEDISH

Page 88: Kite by Philippe Cottenceau FRENCH

Page 89: Kite by Michel Sollin FRENCH

Pages 90-95: Kites by Philippe Cottenceau FRENCH

Page 97: Kites by (left) Philippe Cottenceau and (right) Robert Trépanier

Page 98: Kite by Robert Trépanier CANADIAN

Page 99: Kite by painter Claudio Capelli in Florence ITALIAN

Page 100: David. Kite by Robert Trépanier in Florence, Italy CANADIAN

Page 101: Kite by Robert Trépanier in Piazza del Campo, Siena, Italy CANADIAN

Page 103: Kites by Robert Trépanier CANADIAN

Page 104: Kite by Claudio Capelli ITALIAN

Page 105: Kite by Claudio Capelli at a farm in Tuscany ITALIAN

Pages 106-7: Kites by Robert Trépanier CANADIAN

Page 108: Kites by Robert Trépanier, Philippe Cottenceau, and Claudio Capelli

Page 109: Kites by Philippe Cottenceau and Robert Trépanier

Pages 110-11: Kites by Robert Trépanier CANADIAN

Page 112: Kite by Philippe Cottenceau FRENCH

Page 113: Kites by Claudio Capelli and Robert Trépanier

Page 114: Kite by Claudio Capelli ITALIAN

Pages 115-19: Kites by Robert Trépanier CANADIAN

Page 121: Kites by Jacques Durieu BELGIAN

Page 122: INDONESIAN

Page 123: Kites by Philippe Cottenceau and the Dyna Company from South Carolina

Pages 124-25: Kites by Michel Sollin FRENCH

Page 126: The Kite Club, Schaffhausen SWISS

Page 127: Kite by Li Ruo Xin CHINESE

Page 128: Kite by Fausto Marrocu ITALIAN

Page 129: A Dyna Kite at Cervia International Kite Festival, Italy AMERICAN

Page 130: Train of Small Kites AMERICAN

Page 131: Kite by Philippe Cottenceau FRENCH

Page 132: Kite by Ton Oostveen and Helmut Schiefer BELGIAN/DUTCH

Page 133: Kite by Nick James BRITISH

Page 134: Kite by Kisa GERMAN

Page 135: Kite by Philippe Cottenceau FRENCH

Page 136: Kite by Johan Hallin SWEDISH

Page 137: Kite (detail) by Robert Trépanier CANADIAN

Page 138: Robert Trépanier's sketchbook CANADIAN

Page 139: Kite by Robert Trépanier CANADIAN

Page 141: Kite by Philippe Cottenceau FRENCH

Pages 142-43: Shirone O-dako (Giant Kite) Museum in Japan

Pages 144-45: Rare kite and detail JAPANESE

Pages 146-49: Giant Kite Festival in Shirone, Japan

Page 150: O-dako at Yokaichi, Japan

Page 151: Print JAPANESE

Pages 152-53: Kites CHINESE

Page 154: Kite by Robert Trépanier CANADIAN

Page 155: MALAYSIAN

Page 156: Kite by Michel Sollin FRENCH

Page 157: Kite by Robert Trépanier CANADIAN

Pages 158-59: Train of bird kites CHINESE

Page 160: CHINESE

Page 161: A kite workshop in China

Pages 162-63: Bali INDONESIAN

Pages 164-65: Leaf kites, Muna Island INDONESIAN

Page 166: MALAYSIAN

Page 167: Bali INDONESIAN

Pages 168-69: Wau bulan (Moon-Kites) MALAYSIAN

Pages 170-73: Philippe Cottenceau FRENCH

ACKNOWLEDGMENTS

This poem in images would never have seen daylight without my many friends in the kite-flying fraternity around the world. I would like to express my gratitude to each and every one of them.

A big thank you as well to Virginie Besançon, Renaud Bezombes, and Benoît Nacci.

All the photographs were taken with a Canon EOS 1 camera.

Film: Fuji Sensia.

Development: Photo Labo Service, Avignon, France.

Distribution: Agence Rapho/Eyedea, Paris

Translated from the French by
ANTHONY ROBERTS

Editor, English-language edition:
MAGALI VEILLON

Designer, English-language edition:
SHAWN DAHL

Production Manager, English-language edition:
JULES THOMSON

LIBRARY OF CONGRESS CATALOGING-IN-PUBLICATION DATA
Silvester, Hans Walter.
[Au gré du vent. English]
Into the wind : the art of the kite / by Hans Silvester ; foreword by Eric Fottorino ; text by Philippe Cottenceau.
p. cm.
Includes bibliographical references and index.
ISBN 978-0-8109-9558-1 (alk. paper)
1. Kites—Pictorial works. 2. Kites—History.
3. Photography, Artistic. 4. Kites in art.
I. Cottenceau, Philippe. II. Title.
TL759.S5513 2008
629.133'320222—dc22
2008002412

Copyright © 2008 Éditions de La Martinière, an imprint of La Martinière Groupe, Paris

English translation copyright © 2008 Abrams, New York, and Thames & Hudson, London

Published in North America in 2008 by Abrams, an imprint of Harry N. Abrams, Inc.

PRINTED AND BOUND IN FRANCE
10 9 8 7 6 5 4 3 2 1

HNA
harry n. abrams, inc.
a subsidiary of La Martinière Groupe

115 West 18th Street
New York, NY 10011
www.hnabooks.com

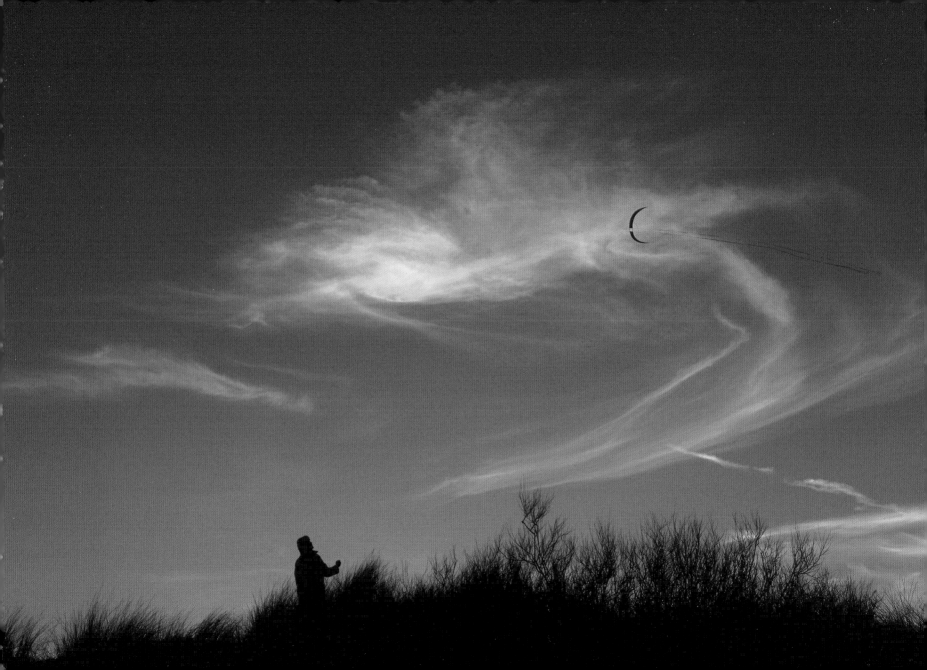

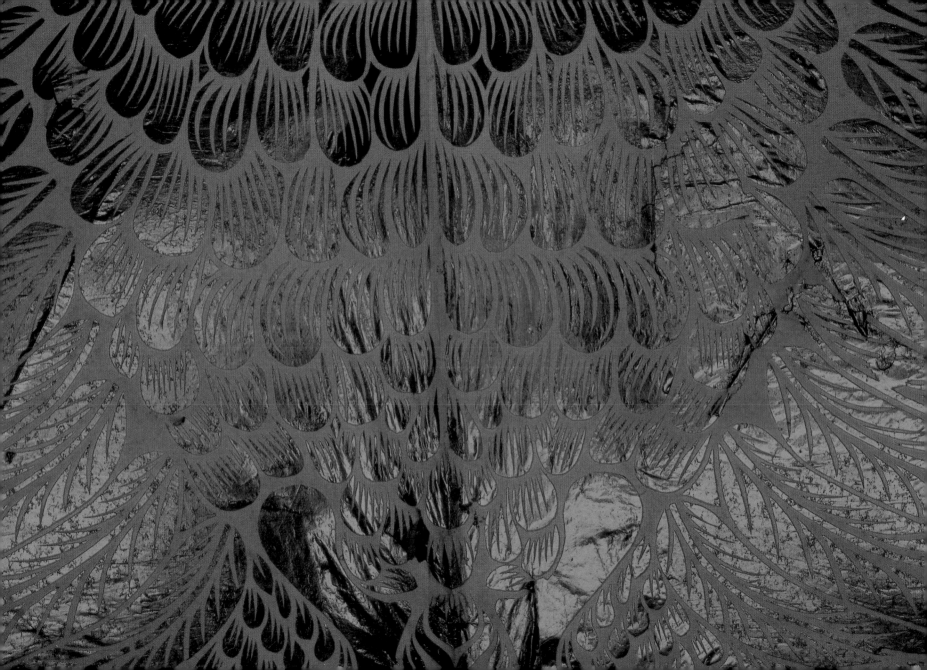